TYPOGRAPHY 1

The
Annual
of The
Type
Directors
Club

TYPOGRAPHY 1

The Annual of The Type Directors Club

WATSON-GUPTILL PUBLICATIONS/NEW YORK

ISBN 0-8230-5535-3

Manufactured in U.S.A.

First Printing, 1980

Distributed outside the U.S.A. and Canada by

Fleetbooks, S.A.
c/o Feffer & Simons, Inc.
100 Park Avenue
New York, New York 10017

Edited by Sharon Lee Ryder and Susan Davis
Typography/Design by Jack G. Tauss
Page layout by Robert Fillie
Photography by William A. Sonntag
Composition by National Photocomposition Services, Inc.

THE CHAIRMAN'S STATEMENT

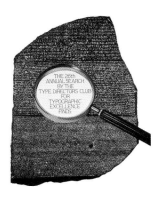

John Luke
Chairman

William Streever
President

Roy Zucca
Board Chairman

The typographic designer practices an ancient art, an art not without its mysteries. For centuries hieroglyphics baffled the world. Then, with the deciphering of the Rosetta Stone, their meaning was unlocked.

An ever-changing artform—clay tablets, pen and ink, woodblocks, hot metal, film, and, today, computers—its technology has advanced. Indeed, just a few years ago technology was rumored to be writing the final chapters of the story—an end to the art of typography as we know it.
But it hasn't happened.

It is both privilege and pleasure to introduce the first hard cover annual of a Type Directors Club Exhibit. This volume amply demonstrates the vigorous health of our craft today. Viewing it, we can say with assurance that the art of typography appears to be approaching the zenith of its long history at an accelerated pace . . . but rather slowly, nevertheless.

This year's selections offer excellence together with great variety. They surely evidence the ingenuity with which today's type directors and designers are solving the graphic problems which now confront them.

In this volume you'll see the selections for TDC-26, the best of some 3,000 entries from around the world—everything from corporate graphics to logos, books, point of purchase, posters, and display advertising. Indeed an exciting collection!

John Luke, Chairman,
TDC-26

Contents

Promotional

Catalogs
Point of Purchase
Book Jackets
Record Albums
Brochures

Advertising

Corporate Graphics
Newspapers and Magazine Display
Billboards
Car Cards

Editorial

Magazines
Newspapers
Books
Company Publications
Special Editions

Informational

Annual Reports
Personal Graphics
Posters
Announcements
Programs
Menus

The Type Directors Club (TDC) is celebrating its 26th annual exhibition.

The Latin alphabet has 26 characters.

It was inevitable that the length of existence of the TDC should eventually catch up to the length of the Latin alphabet.

It was also inevitable that some lucky designer would be given the opportunity to exploit this coincidence.

So, herewith is my effort to extoll the virtues of the past 25 years of American typography and, at the same time, heap praise upon The Type Directors Club for the responsive and responsible role it has played in making typography the 20th century's newest art form or, at the very least, a highly esoteric craft.

The realization came to many of us in the early 50s that type was not just a mechanical means of setting words on a page, but was, rather, a creative and expressive instrument in the hands of imaginative designers. The Type Directors Club and its members recognized this as fact in 1955 when they organized their first annual exhibition to honor those practitioners whose works made a sizable contribution to the advancement of innovative typographic design. It was, and is, indeed an honor to be included in these selective and prestigious exhibitions.

The TDC, through its efforts, has created an inspirational atmosphere in which designers can effectively expand their typographic talents, and it has, along with the new typographic technologies, influenced what we endearingly refer to as the "American Typographic Revolution."

It was an enlightening experience for me to go back over the past 25 TDC catalogs and ponder the amazing typographic changes that have taken place. In no other craft, in no other art form, have changes been so obvious.

It is befitting that The Type Directors Club, in celebrating the conclusion of 25 years in business, should record its 26th annual exhibition in permanent form for the enlightenment of future generations of typophiles.

I applaud the publication of **Typography 1.** Herb Lubalin

Chairman & Judges

ROBERT ANTHONY

Under Robert Anthony's direction, and in large measure due to his graphic skills, the design and merchandising organization Robert Anthony, Inc. has achieved a national reputation in the financial world, as well as one for effective promotional materials and for skill in the graphic phases of publishing.

DANIEL HABERMAN

Daniel Haberman, a successful designer and trained typographer, entered the new field of systems composition early. He has played an active role in the development of type on film and in computers. At the company he heads these new techniques were proved and improved under commercial conditions.

ALICE KOETH

For more than ten years "Alice ," as she chooses to be known professionally, has designed and produced the display posters for exhibitions at the prestigious Pierpont Morgan Library in New York. Internationally recognized as a calligrapher and designer, her highly respected work creates trends.

GENE KRACKEHL

A former art director/designer at NBC, now vice-president and design director of Michael John Associates, the chairman of TDC-25 served as "available alternate" on the day of judging. Travel demands of other judges did indeed cause him to be pressed into action during the first and the last hour of judging.

JOHN MASSEY

GERARD (JERRY) O'NEILL

JACK TAUSS

Medalist and award-winner in many competitions, a sought-after judge, and a creative designer of international reputation, John Massey qualifies by experience as a true generalist of graphics, evidenced by the quality and volume of work turned out under his guidance as director of communications at Container Corp.

For more than twenty-five years, prior to his recent retirement, Jerry O'Neill's specification of type for top creative work in major advertising campaigns at the world's largest advertising agency indicates the typographic ability and technical skill of this judge as leader rather than follower in type usage.

The broad experience and professional acclaim accorded this specialist in book design and fine printing are evidenced by Jack Tauss's versatile designs and illustrations, his innumerable awards, and his position as creative director of The Franklin Library, all of which contributed to his selection as designer of this volume.

Promotional

Catalogs
Point of Purchase
Book Jackets
Record Albums
Brochures

Champion Papers
The Printing Salesman's Herald
Book 41

TYPOGRAPHY/DESIGN	Tomás Gonda
TYPE SUPPLIER	Cardinal Type Service/Rapoport
STUDIO	Plumb Design Group
CLIENT	Champion Papers, Division of
	Champion International Corp.
PRINCIPAL TYPE	Helvetica/Century—Interchanged
DIMENSIONS	8½ × 11″ (22 × 28 cm)

TYPOGRAPHY/DESIGN Jack Hough
TYPE SUPPLIER Hennegan
STUDIO Jack Hough Associates
CLIENT Champion Papers, Division of
 Champion International Corp.

PRINCIPAL TYPE Garamond
DIMENSIONS 12 × 12″ (30 × 30 cm) Promotional/15

Creative Psychiatry

15 Creativity and the Aged
James L. Foy, M.D.

TYPOGRAPHY/DESIGN	Ron Vareltzis
TYPE SUPPLIER	Empire Typographers
STUDIO	Ciba-Geigy Design
CLIENT	Geigy Pharmaceuticals
PRINCIPAL TYPE	Helvetica
DIMENSIONS	6½ × 10½″ (17 × 27 cm)

Once Upon a Time

TYPOGRAPHY	James Marrin
DESIGN	Fred Wilmshurst/Judith Endler
TYPE SUPPLIER	Phototype House
STUDIO	Advertising Designers, Inc.
CLIENT	Security Pacific Bank
	Fiduciary Services Group
PRINCIPAL TYPE	Cochin
DIMENSIONS	8½ × 11″ (22 × 28 cm)

TYPOGRAPHY/DESIGN	Ernie Smith
TYPE SUPPLIER	Pastore DePamphilis Rampone
STUDIO	Herb Lubalin Associates Inc.
CLIENT	Touche Ross
PRINCIPAL TYPE	Body: Korinna (ITC)
	Heads: Korinna Kursiv (ITC)
DIMENSIONS	17 × 11" (43 × 28 cm)

Decisions.

TYPOGRAPHY/DESIGN Steven Sessions
TYPE SUPPLIER Professional Typographers
AGENCY Baxter + Korge, Inc.
CLIENT Trans Commonwealth Associates

PRINCIPAL TYPE Palatino
DIMENSIONS 17 × 11½" (43 × 29 cm) Promotional/19

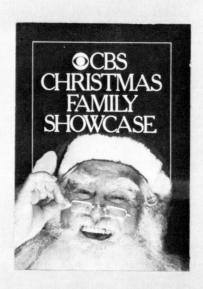

TYPOGRAPHY/DESIGN	Lou Dorfsman/John Hite
TYPE SUPPLIER	TypoGraphics Communications, Inc.
AGENCY	CBS/Broadcast Group
CLIENT	CBS Television Stations
PRINCIPAL TYPE	Body: ITC Cheltenham Light
	Heads: ITC Cheltenham Book
DIMENSIONS	12¼ × 12¼″ (31 × 31 cm)

Curtis Rag

TYPOGRAPHY/DESIGN Cameron Hyers
TYPE SUPPLIER Typographic House, Boston
AGENCY Hyers/Smith Inc.
CLIENT Curtis Paper

PRINCIPAL TYPE Goudy Old Style
DIMENSIONS 8½ × 11″ (22 × 28 cm)

Promotional/21

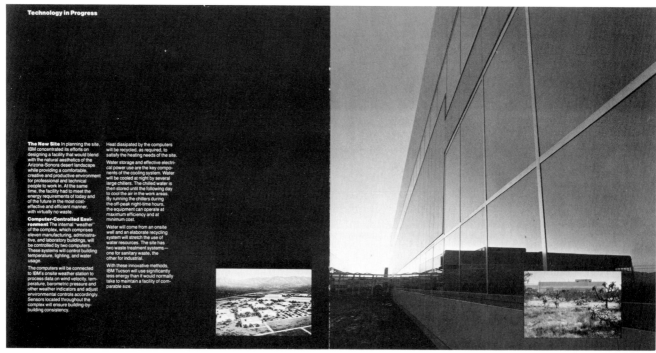

TYPOGRAPHY/DESIGN	Kurt W. Gibson
TYPE SUPPLIER	Tucson Type
STUDIO	IBM Tucson Design Center
CLIENT	IBM
PRINCIPAL TYPE	Helvetica
DIMENSIONS	8¼ × 8¼″ (21 × 21 cm)

TYPOGRAPHY/DESIGN Jerry Herring
TYPE SUPPLIER Typeworks, Inc.
CALLIGRAPHER Jerry Herring/Rick Gardner
STUDIO/CLIENT Herring Design

PRINCIPAL TYPE Garamond #3
DIMENSIONS 7 × 9½" (18 × 24 cm)

DESIGN/CALLIGRAPHER David Quay
STUDIO David Quay Lettering Designer
CLIENT Alison Daines, Penthouse GB

24/Promotional DIMENSIONS 300 × 435 mm (11¾ × 17⅛″)

ZANDERS Feinpapiere GmbH & Co
D-5060 Bergisch Gladbach 2

Der Zanders-Kalender für 1979 präsentiert auf 12 Blättern geprägte und gedruckte Formen, die in enger Zusammenarbeit zwischen dem genialen französischen Künstler Georges Braque und dem Juwelier und Maître Lapidaire Heger de Loewenfeld entstanden.

Grundlagen sind Schmuckstücke, die Braque in seiner letzten Schaffensperiode entworfen hat, einer Periode, die Andrée Malraux, Ministre d'Etat chargé des affaires culturelles, anläßlich der ersten Ausstellung dieser einmaligen Kunstwerke im Musée du Louvre als die „ultimate metamorphosis of Georges Braque" bezeichnete.

Heger de Loewenfeld war der „companion", der diese anspruchsvollen Träume in Gold und Edelstein realisierte.

Die in diesem Kalender gezeigten Umsetzungen einiger dieser Schöpfungen in eine geprägte und gedruckte Form gehen ebenfalls auf gemeinsame Absichten von Braque und Heger de Loewenfeld zurück. Unverzichtbare Basis waren dabei die technologischen Eigenschaften von Chromolux sowie der heute erreichte hohe Stand der Druck- und Prägetechnik.

Die Namen der einzelnen Kunstwerke sind von den Künstlern in Verehrung der griechischen Götterwelt gewählt worden.

Zanders als Herausgeber des Kalenders „Bijoux de Braque" fühlt sich den Künstlern zum Dank verpflichtet. Gleichzeitig hoffen wir, unseren Freunden im Jahre des 150-jährigen Jubiläums unserer Firma eine besondere Freude zu machen.

The twelve sheets of the Zanders Calendar for 1979 present embossed and printed motifs which are the outcome of close co-operation between the outstanding French artist Georges Braque and jeweller and master stone-cutter Heger de Loewenfeld.

The basis of this collection are decorative stones designed by Braque during his last creative period, a period described by André Malraux, Ministre d'Etat chargé des affaires culturelles, on the occasion of the first exhibition of these unique objets d'art in the Musée du Louvre, as "the ultimate metamorphosis of Georges Braque."

Heger de Loewenfeld was the "companion" who translated these inspired dreams into gold and precious stones.

The further transformation of certain of these creations into embossed and printed form is also based on the joint intentions of Braque and Heger de Loewenfeld. In the execution of this intention, indispensable prerequisites were the technological characteristics of Chromolux and present-day high standards of printing and embossing techniques.

The artists chose the titles of their works in honour of the Gods of Ancient Greece.

As the publishers of the "Bijoux de Braque", Zanders feel that they are bound to extend their thanks to the artists. We hope at the same time to offer our friends something special on the occasion of our firm's 150th anniversary.

Le calendrier Zanders 1979 représente sur douze feuillets des formes imprimées et gaufrées résultant de l'étroite collaboration entre le génial artiste français Georges Braque et le maître lapidaire Heger de Loewenfeld.

Les documents de base sont des maquettes dont sont issues les «Bijoux» de Braque, ultime métamorphose, présentés au Louvres et célébrés par André Malraux alors Ministre d'Etat chargé des affaires culturelles comme son apothéose.

Ce rêve a été matérialisé en or et pierres précieuses par son compagnon Heger de Loewenfeld.

La reproduction de ces créations originales célèbre l'esprit dans lequel Braque et Loewenfeld ont œuvre. La haute technicité du chromolux et les techniques de pointes d'impression et de gaufrage ont été nécessaire à cette réalisation.

Les noms de ces joyaux ont été fixés par les auteurs en hommage aux dieux et déesses de la mythologie grecque, nourrissière de notre civilisation occidentale.

Zanders, éditeur de cet hommage aux bijoux de Braque, se sent redevable aux artistes.

Nous espérons en cette année du 150ème aniversaire de notre société vous faire partager notre émotion.

Il calendario-Zanders 1979 presenta forme stampate e in rilievo su dodici fogli, nate dalla stretta collaborazione fra il geniale artista francese Georges Braque ed il gioelliere e Maitre Lapidaire Heger de Loewenfeld.

L'idea originaria é basata su preziosi disegnati da Braque nella sua ultima fase creativa. Fase che André Malraux, Ministre d'Etat chargé des affaires culturelles, in occasione della prima esposizione di quelle eccezionali opere d'arte al Musée du Louvre, definì la «ultimate metamorphosis of Georges Braque». Heger de Loewenfeld fù il «companion», che trasformo questi sublimi sogni in oro e preziosi.

La trasposizione di alcune di queste opere in stampe e coniature, raccolte in questo calendario nascono pure da una comune idea di Braque e Heger de Loewenfeld. Fondamentali per la realizzazione sono risultate le caratteristiche tecnologiche del Chromolux, come anche l'alto livello raggiunto dalla tecnica di stampa e coniatura.

La scelta dei nomi delle singole opere é un omaggio degli artisti alla mitologia greca.

Zanders come editore del calendario «Bijoux de Braque» esprime il suo ringraziamento agli artisti. Nello stesso tempo nutriamo la speranza di poter offrire un particolare piacere a tutti i nostri amici nel 150° anniversario di fondazione della nostra ditta.

TYPOGRAPHY/STUDIO	K. Winterhager
DESIGN	Braque-Heger de Lowenfeld/
	K. Winterhager
TYPE SUPPLIER	Manfred Leyhausen, Dusseldorf
CLIENT	Zanders Feinpapiere GmbH

TYPOGRAPHY/DESIGN Theo Welti/Jacqueline Rose
TYPE SUPPLIER Empire Typographers
CALLIGRAPHER Theo Welti
STUDIO 20.20 Vision,
 Div. of Welti & Rose Advertising, Inc.
CLIENT IBM Corporation, Data Processing Div.

PRINCIPAL TYPE Sabon
DIMENSIONS 9⅛ × 13¼″ (23 × 34 cm)

The IBM 5110 Computing System: **A powerful small computer to match your business needs**

IBM

TYPOGRAPHY/DESIGN	Lou Fiorentino/Richard Moore
TYPE SUPPLIER	Royal Composing Room Inc.
CALLIGRAPHER	Stanislaw Fernandes
STUDIO	Muir Cornelius Moore
CLIENT	IBM General Business Group/International
PRINCIPAL TYPE	Body: Helvetica Light Heads: Helvetica Medium
DIMENSIONS	11¾ × 8⅛″ (30 × 21 cm)

Promotional/27

TYPOGRAPHY David Hillman
DESIGN Colin Forbes
TYPE SUPPLIER Face Photosetting
STUDIO Pentagram Design
CLIENT Watson-Guptill Publications

PRINCIPAL TYPE Torino
DIMENSIONS 9½ × 10¼″ (24 × 26 cm)

TYPOGRAPHY/DESIGN Jim McWilliams
TYPE SUPPLIER/STUDIO Design Works!
CLIENT Sterling and Francine Clark
Art Institute

PRINCIPAL TYPE Sabon
DIMENSIONS $9\frac{9}{16} \times 9\frac{9}{16}''$ (24 × 24 cm) Promotional/29

DESIGN/CALLIGRAPHER Yukio Kanise
STUDIO Kanise Design Office Inc.
CLIENT GROUP TYPO-EYE

DESIGN/CALLIGRAPHER Yukio Kanise
STUDIO Kanise Design Office Inc.
CLIENT GROUP TYPO-EYE

Promotional/31

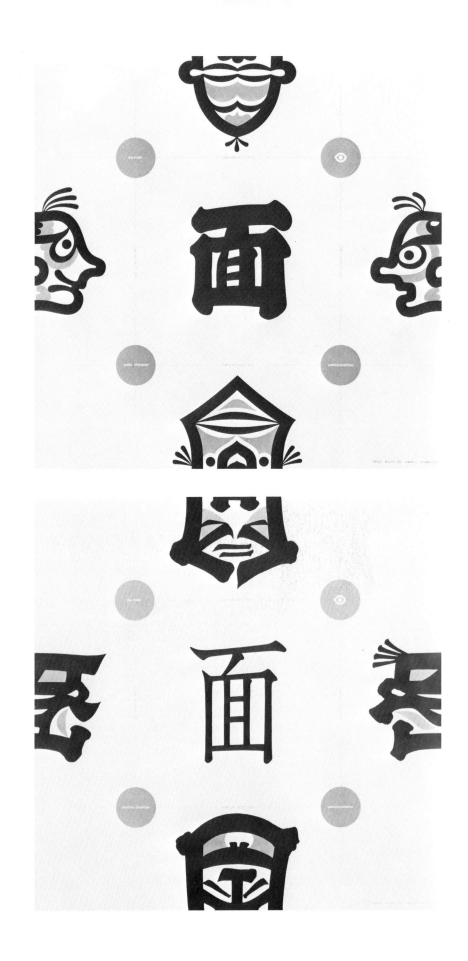

DESIGN/CALLIGRAPHER Yoshihiro Yoshida
CLIENT GROUP TYPO-EYE

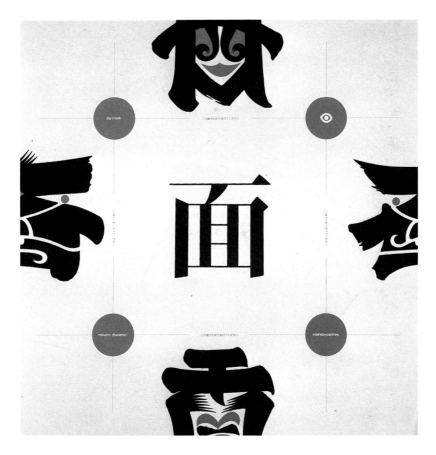

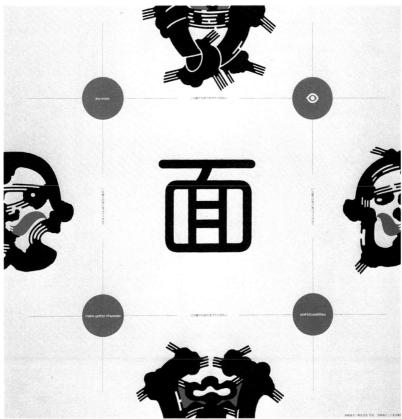

DESIGN/CALLIGRAPHER Yoshihiro Yoshida
CLIENT GROUP TYPO-EYE

Clinical Focus

Metoprolol in Hypertension

A Round-Table Discussion at
Mt. Sinai Hospital, New York, New York

Aram V. Chobanian, MD, Moderator

TYPOGRAPHY/DESIGN Bob Paganucci
TYPE SUPPLIER Haber Typographers
STUDIO Bob Paganucci
CLIENT Ciba-Geigy

PRINCIPAL TYPE Helvetica
DIMENSIONS 5½ × 12″ (14 × 30 cm)

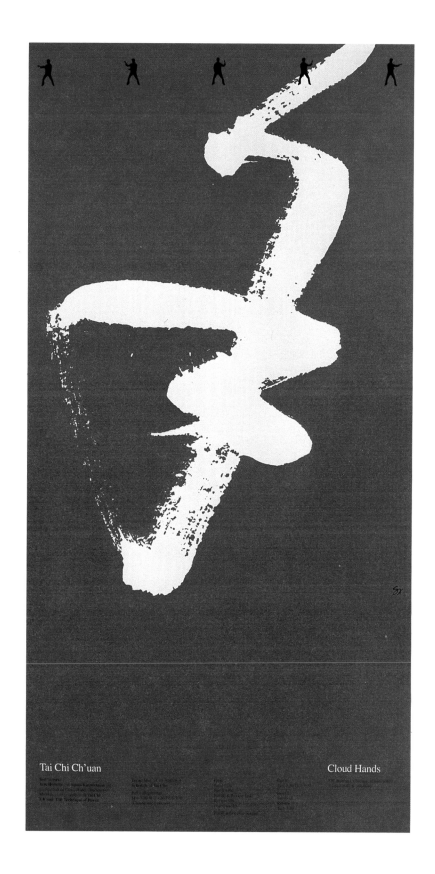

Tai Chi Ch'uan

Cloud Hands

TYPOGRAPHY/DESIGN Joseph M. Essex
TYPE SUPPLIER Shore Typographers
AGENCY Burson · Marsteller/Design Group
CLIENT Cloud Hands

PRINCIPAL TYPE Times Roman
DIMENSIONS 14 × 28″ (36 × 71 cm)

Promotional/35

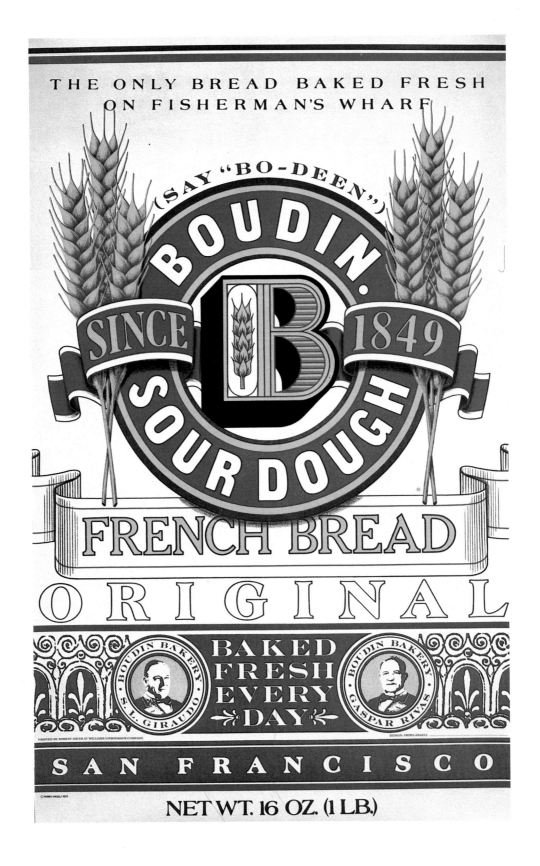

TYPOGRAPHY/DESIGN	Primo Angeli
TYPE SUPPLIER	Repro-Type
CALLIGRAPHER	Mark Jones/Rene Yung
STUDIO	Primo Angeli Graphics
CLIENT	Boudin Bakeries
DIMENSIONS	21 × 34″ (53 × 86 cm)

TYPOGRAPHY/DESIGN Primo Angeli/Ferris Crane
TYPE SUPPLIER Repro-Type
STUDIO Primo Angeli Graphics
CLIENT Brustlin Workshop

DIMENSIONS 5 × 8″ (13 × 20 cm)
Display Piece: 12 × 10″ (30 × 25 cm) Promotional/37

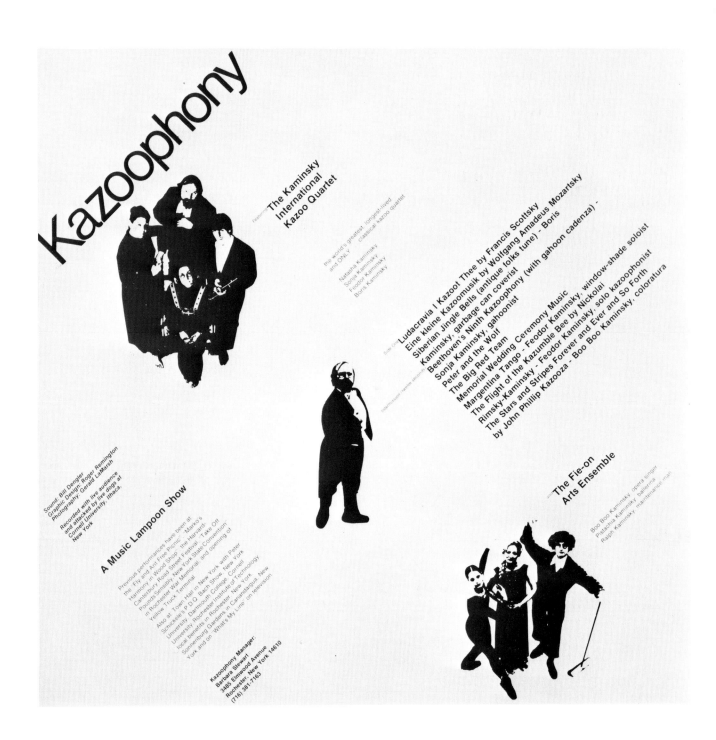

Kazoophony

The Kaminsky International Kazoo Quartet

Featuring... the world's greatest, longest-lived and ONLY classical kazoo quartet

Natasha Kaminsky
Sonja Kaminsky
Feodor Kaminsky
Boris Kaminsky

Side two: Ludacravia I Kazoot Thee by Francis Scottsky
Eine kleine Kazoomusik by Wolfgang Amadeus Mozartsky
Siberian Jingle Bells (antique folks tune) - Boris
Kaminsky, garbage can coverist
Beethoven's Ninth Kazoophony (with gahoon cadenza) -
Sonja Kaminsky, gahoonist
Peter and the Wolf
The Big Red Team
Memorial Wedding Ceremony Music
Margentina Tango - Feodor Kaminsky, window-shade soloist
The Flight of the Kazumble Bee by Nickolai
Rimsky-Kaminsky - Feodor Kaminsky, solo kazoophonist
The Stars and Stripes Forever and Ever and So Forth
by John Phillip Kazooza - Boo Boo Kaminsky, coloratura

Intermission intertwine second intermission second intertwine

Sound: Bill Dengler
Graphic Design: Roger Remington
Photography: Gerald LaMarsh
Recorded with live audience
and attacked by live dogs at
Cornell University, Ithaca,
New York

A Music Lampoon Show

Previous performances have been at
the Fly and Ant Free Picnic - Marko's
Harmony in Wood Shop - the Harvard,
Canterbury Road Street Festival - Take Off
Pounds Sensibly New York State Convention
in Rochester Yellow Truck Terminal
Also at Town Hall in New York with Peter
Schickele's P.D.Q. Bach Show, New York
University, Dartmouth College, Cornell
local benefits in Rochester, New York
Sonnenburg Gardens in Canandaigua, New
York and on "What's My Line" on television

Kazoophony Manager:
Barbara Stewart
3485 Elmwood Avenue
Rochester, New York 14610
(716) 381-7163

The Fie-on Arts Ensemble

featuring... Boo Boo Kaminsky, opera singer
Pistachia Kaminsky, ballerina
Ralph Kaminsky, maintenance man

TYPOGRAPHY/DESIGN R. Roger Remington
TYPE SUPPLIER Setronics Ltd.
STUDIO Communications±
CLIENT Kaminsky International Kazoo Quartet

PRINCIPAL TYPE Helvetica
DIMENSIONS 12 × 12″ (30 × 30 cm)

TYPOGRAPHY/DESIGN	Ely Besalel
TYPE SUPPLIER	Joe Electro
STUDIO	Besalel, Ltd.
CLIENT	Columbia Special Products/CBS Records
PRINCIPAL TYPE	Goudy Bold
DIMENSIONS	12⅜ × 12⅜″ (31 × 31 cm)

DESIGN	Gerard Huerta/John Berg/
	Henrietta Condak
CALLIGRAPHER	Gerard Huerta
STUDIO	Gerard Huerta Design
CLIENT	CBS Records
DIMENSIONS	12½ × 12½" (32 × 32 cm)

40/Promotional

TYPOGRAPHY/DESIGN Gerard Huerta/Abie Sussman
CALLIGRAPHER Gerard Huerta
STUDIO Gerard Huerta Design
CLIENT Polydor Records
DIMENSIONS 12½ × 12½″ (32 × 32 cm)

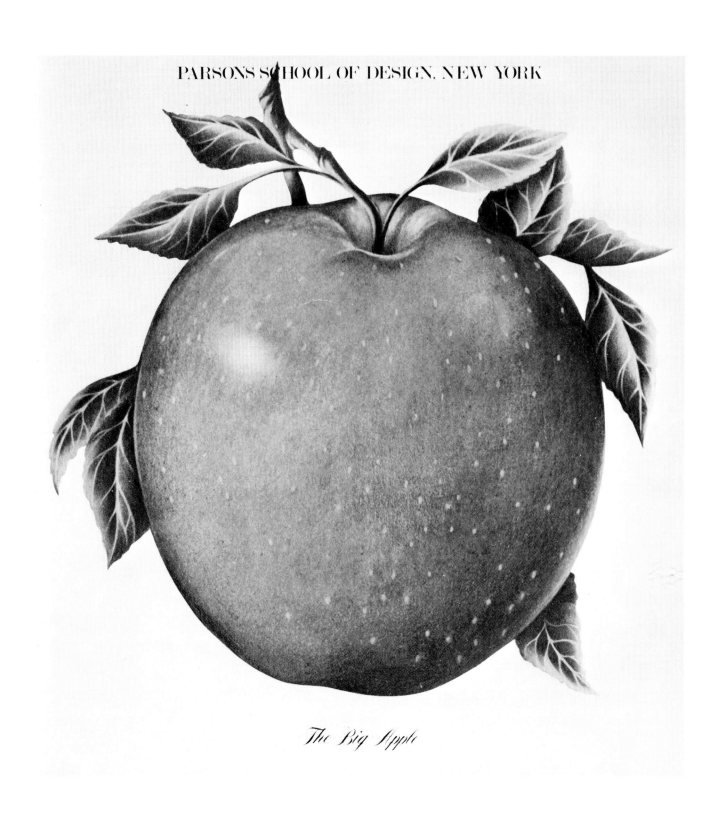

The Big Apple

TYPOGRAPHY/DESIGN	Cipe Pineles Burtin
TYPE SUPPLIER	In House
STUDIO/CLIENT	Parsons School of Design
PRINCIPAL TYPE	Helvetica

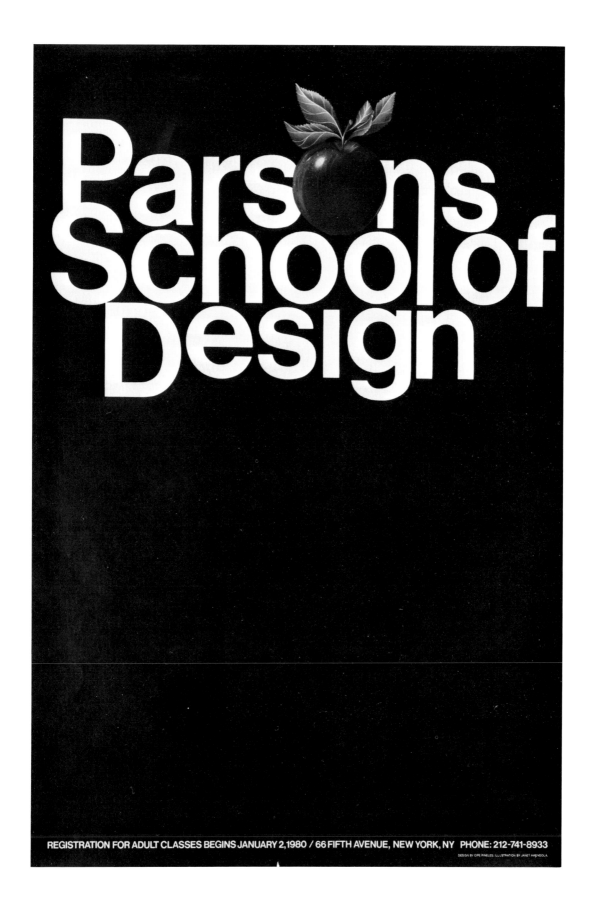

TYPOGRAPHY/DESIGN Cipe Pineles Burtin
TYPE SUPPLIER In House
STUDIO/CLIENT Parsons School of Design

PRINCIPAL TYPE Helvetica

TYPEFOLIO

PHOTO-LETTERING,INC · 216E45ST · NYCIOOI7 · 212-MU2-2345

DESIGN Edward Benguiat/Tom Vasiliow
TYPE SUPPLIER/CLIENT Photo-Lettering, Inc.

PRINCIPAL TYPE Benguiat Book
DIMENSIONS 9 ¼ × 9¼" (24 × 24 cm)

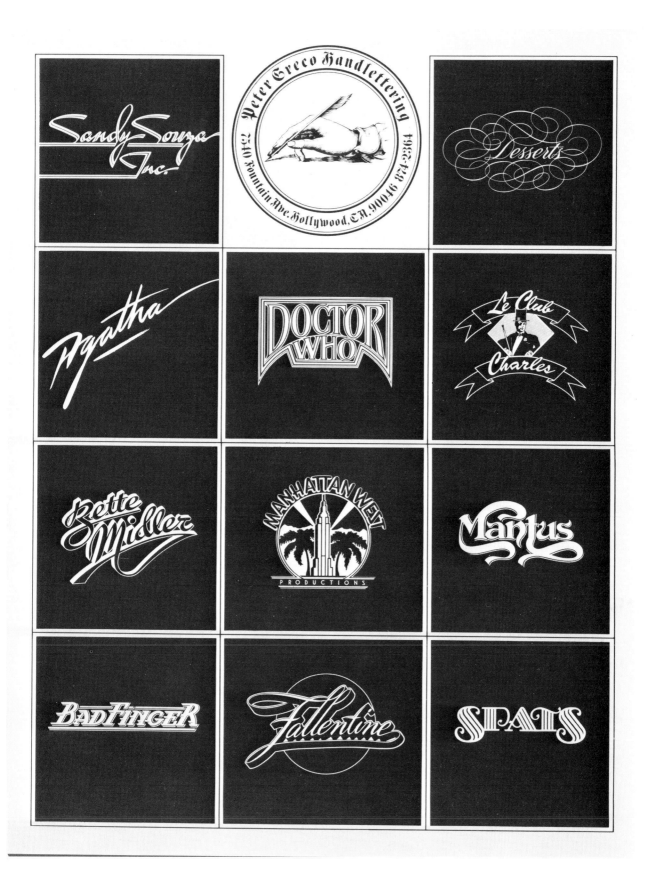

DESIGN/CALLIGRAPHER Peter Greco
TYPE SUPPLIER Photo-Lettering, Inc.
STUDIO/CLIENT Peter Greco Handlettering

DIMENSIONS 8½ × 11″ (22 × 28 cm)

M.B.L. Publishing Company Limited

TYPOGRAPHY/DESIGN John Lee
TYPE SUPPLIER House of Lind
AGENCY John Lee Associates
CLIENT M.B.L. Publishing Limited

PRINCIPAL TYPE Body: Goudy Oldstyle
 Heads: Trump Medieval

 DIMENSIONS 14½ × 10¼″ (37 × 26 cm)

TYPOGRAPHY/DESIGN/
CALLIGRAPHER Sean Farley
AGENCY D. J. Moore Advertising Inc.
CLIENT L'Ecole Ltd.

DIMENSIONS 8 × 11″ (20 × 28 cm) Promotional/47

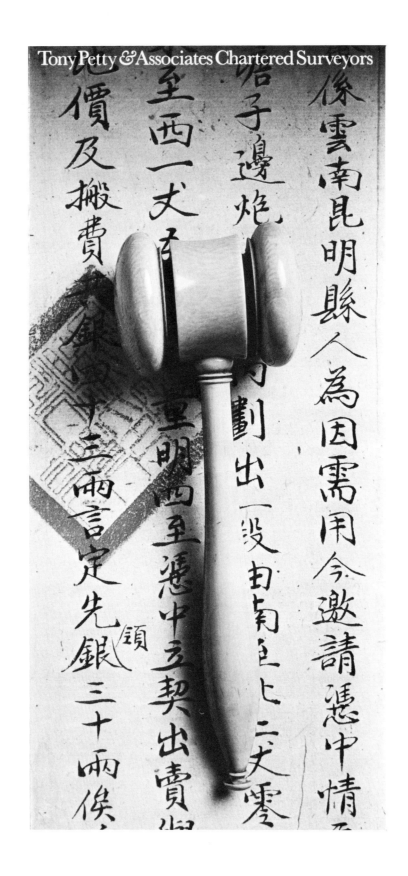

Tony Petty & Associates Chartered Surveyors

DESIGN	Henry Steiner
TYPE SUPPLIER	Asco Trade Typesetting Ltd.
STUDIO	Graphic Communication, Ltd., Hong Kong
CLIENT	Tony Petty & Associates
PRINCIPAL TYPE	Baskerville
DIMENSIONS	153 × 330 mm (6 × 13")

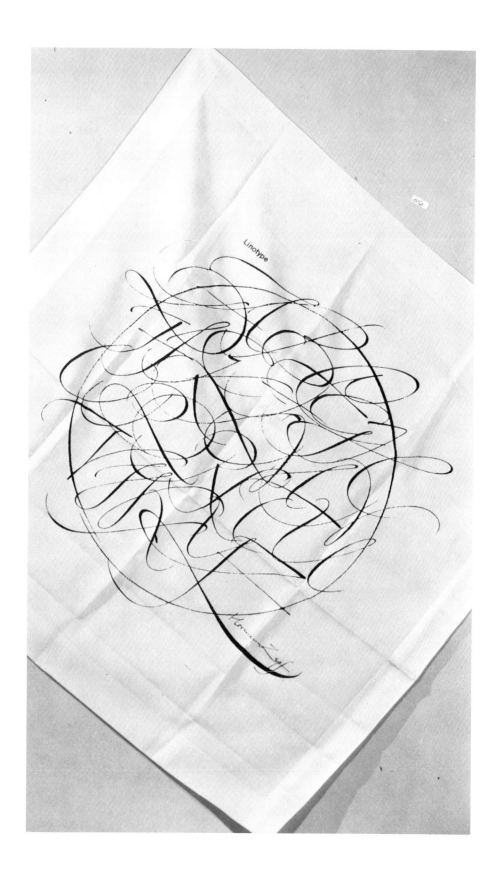

DESIGN H. Christ, Frankfurt
CALLIGRAPHER Hermann Zapf, Darmstadt
CLIENT Mergenthaler Linotype, GmbH, Eschborn
DIMENSIONS 30 × 30″ (76 × 76 cm) Promotional/49

ABCDEFG
HIJKLLLM
NOPQRST
UVWXYZ
↑1234567
890;$?!*&

ORIGINAL TYPOGRAPHY FOR THE COCA-COLA COMPANY DESIGNED BY RUPERT/JENSEN & ASSOCIATES AND HERB LUBALIN ASSOCIATES.

TYPOGRAPHY/DESIGN	John Rupert/Tony DiSpigna/
	Ane Nelson/John Grogan
STUDIO	Rupert/Jensen & Associates
CLIENT	The Coca-Cola Company
DIMENSIONS	14 × 20½" (36 × 52 cm)

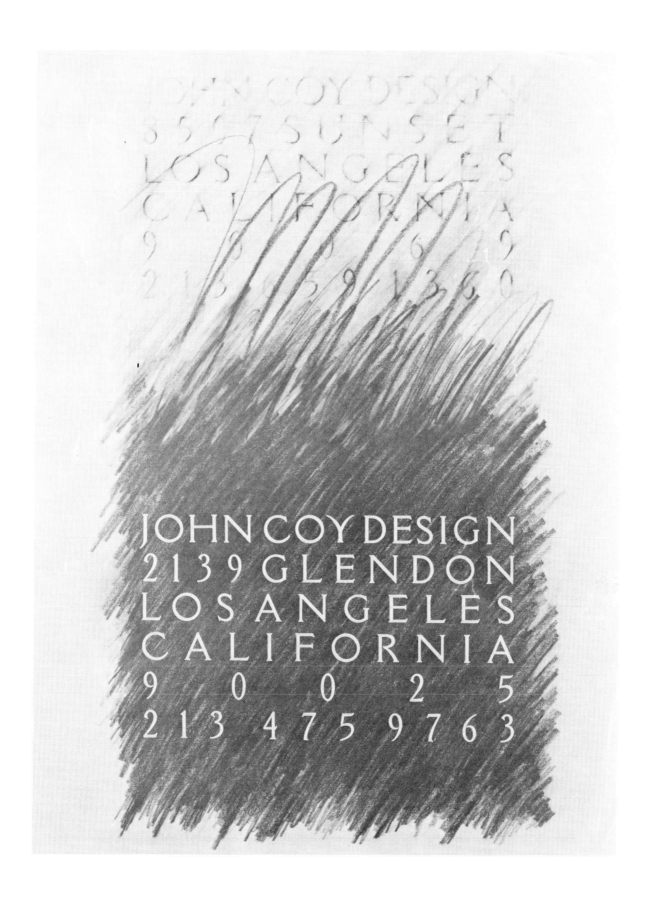

JOHN COY DESIGN
2139 GLENDON
LOS ANGELES
CALIFORNIA
9 0 0 2 5
2 1 3 4 7 5 9 7 6 3

TYPOGRAPHY/DESIGN John Coy/Maryl Lavelle
TYPE SUPPLIER Vernon Simpson Typographers, Inc.
STUDIO/CLIENT John Coy Design

PRINCIPAL TYPE Della Robbia
DIMENSIONS 14 × 17" (36 × 43 cm)

TYPOGRAPHY/DESIGN	Cheryl Heller
TYPE SUPPLIER	Typographic House, Boston
AGENCY	Gunn Associates
CLIENT	Nyloprint, BASF
PRINCIPAL TYPE	Kabel Heavy
DIMENSIONS	6 × 12" (15 × 30 cm)

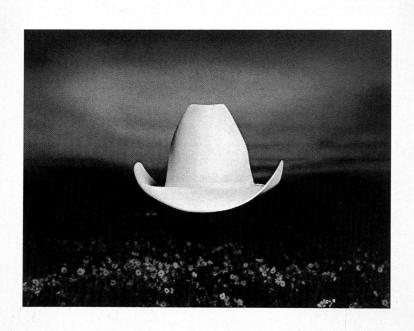

TYPOGRAPHY/DESIGN Jack Evans/Steve Rubin
TYPE SUPPLIER Express Typesetting
CALLIGRAPHER Alberto Tomas
STUDIO Unigraphics, Inc.
CLIENT Randy Heady & Company Realtors

PRINCIPAL TYPE Palatino
DIMENSIONS 26¾ × 12″ (68 × 30 cm)

Vivitar. Photographic Products

Fall, 1979

TYPOGRAPHY/DESIGN	Keith Bright/Kara Blohm
TYPE SUPPLIER	Andresen Typographics
STUDIO	Bright & Agate, Inc.
CLIENT	Vivitar Corporation
PRINCIPAL TYPE	Helvetica
DIMENSIONS	17 × 11″ (43 × 28 cm)

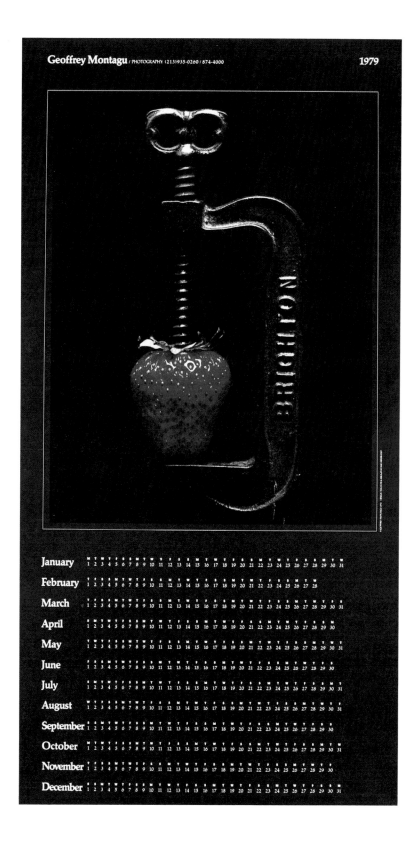

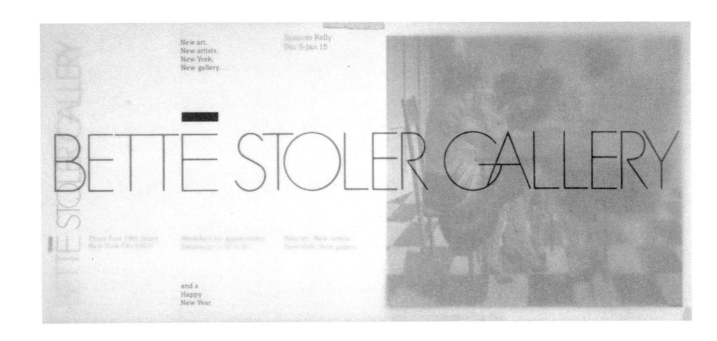

BETTE STOLER GALLERY

New art.
New artists.
New York.
New gallery…

Spencer Kelly
Dec 5–Jan 15

Three East 54th Street
New York City 10022

Weekdays by appointment
Saturdays 11:30–5:30

New art. New artists.
New York. New gallery.

and a
Happy
New Year.

DESIGN	Robert Cooney
TYPE SUPPLIER	IGI
STUDIO	R. A. Cooney, Inc.
CLIENT	Bette Stoler Gallery
PRINCIPAL TYPE	Italia
DIMENSIONS	4 × 9″ (10 × 23 cm)

TYPOGRAPHY/DESIGN/
CALLIGRAPHER Thomas Morris
TYPE SUPPLIER Randolph, Harris & Ridenhower Type
STUDIO/CLIENT Sharpshooter Studios

PRINCIPAL TYPE Avant Garde/Garamond Italic
DIMENSIONS 6 × 9" (15 × 23 cm) Promotional/57

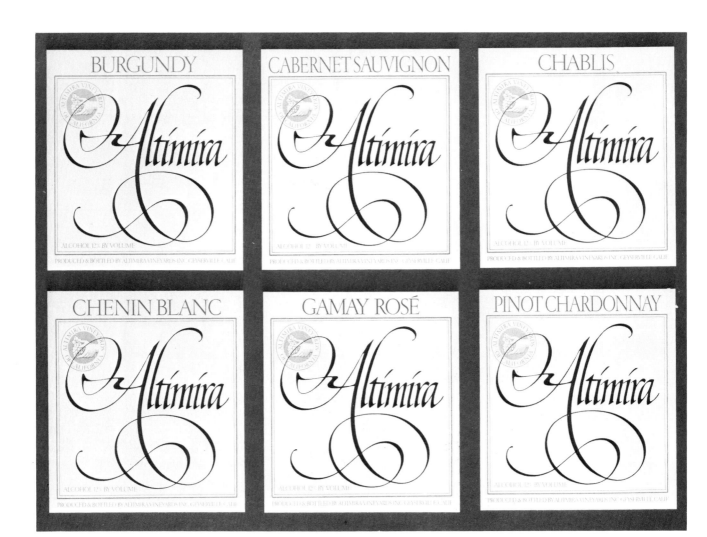

TYPOGRAPHY/DESIGN	Bill Bundzak
CALLIGRAPHER	Ray Boguslav/Emil Biemann
AGENCY	Young Goldman Young, Inc.
CLIENT	Altimira
PRINCIPAL TYPE	Body: Calligraphy
	Heads: Garamond Light
DIMENSIONS	4$^{1}/_{16}$ × 4$^{5}/_{16}$″ (10 × 11 cm)

WURDƧ TEN

WURDƧ — a grafic reprezentashun uv
a sound aır searæƨ uv soundƨ

WURDƧ TEN — stewdentƨ uz wurdƨ
too crææt imajez in ɟhe Scool uv
Viƨual Artƨ 10th literaræ publicashun

Enæ stewdent hoo wood liek too submit matearæal faır
publicashun in WURDƧ shud send aır bring it too Martin
Smith, Facultæ Adviƨor, aır Timothy Binkley, Chairman
uv the Humanitæƨ Dæpartment, by ɟhe end uv ɟhe Faıl
semester C/o ɟhe Scool. Wurks uv boɟh ficshun aır non-
ficshun wil bæ considerd. If u wood liek yor manuscript
returnd, plæeaƨ encloz a stampd, self-adresd onvelop.

Initial Teaching Alphabet designed by Sir James Pitman A WORDS Publication. Printed by the School of Visual Arts. Courtesy of the Visual Arts Press. Art Director: Richard Wilde Designed by Sue B. Taube

TYPOGRAPHY/DESIGN	Richard Wilde/Sue Taube
TYPE SUPPLIER	Cardinal Type Service, Inc.
STUDIO	School of Visual Arts Publications
CLIENT	School of Visual Arts, Humanities Department
PRINCIPAL TYPE	Garamond
DIMENSIONS	18 × 13½" (46 × 34 cm)

The most thing I would expect
would be out of my self. To be able
to live by the law. And to
appreciate them. To become
a responsible person and stand
on my one two feet. And to
hold a job and appreciate it.
and to develope my
character.

If you have a drug or behavioral
problem you're serious about solving,
or if you'd like to help someone
who has, contact Cenikor.

Cenikor works.

In Houston: 228-4447
In Ft. Worth: 332-1044
In Denver: 234-1288

TYPOGRAPHY/DESIGN	Jerry Herring
TYPE SUPPLIER	Words & Things
STUDIO	Herring Design
CLIENT	Cenikor Foundation
PRINCIPAL TYPE	Body: American Typewriter
	Heads: American Typewriter Bold
DIMENSIONS	8½ × 11" (22 × 28 cm)

A T
C R A N B R O O K

D O W N T O W N
D E T R O I T

T W E N T Y
O N E
A R T I S T S

'7 9

TYPOGRAPHY/DESIGN Katherine McCoy/James A. Houff
TYPE SUPPLIER Lettergraphics
CALLIGRAPHER James A. Houff
STUDIO Cranbrook Academy of Art/Design Dept.
CLIENT Cranbrook Academy of Art Museum

PRINCIPAL TYPE Helvetica/Univers
DIMENSIONS 9 × 10″ (23 × 25 cm) Promotional/61

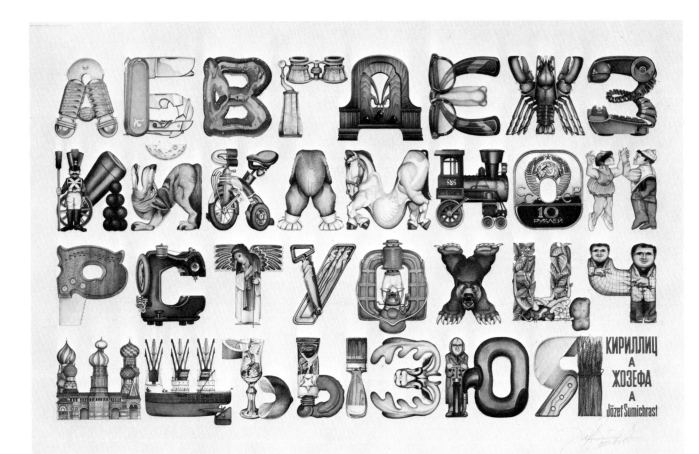

TYPOGRAPHY/DESIGN/
CALLIGRAPHER Jözef Sumichrast
STUDIO Jözef Sumichrast, Inc.

DIMENSIONS 38 × 25″ (97 × 64 cm)

ITC Zapf Chancery Light, Medium, Demi & Bold With Light & Medium Italic.

ITC ZAPF CHANCERY LIGHT

abcdefghijklmnopqr
stuvwxyzABCDEF
GHIJKLMNOPQR
STUVWXYZ1234
567890123456789 0
&$¢£%AÇÐEŁØÆ
Œßaçdełøæœ:;,.!¡?¿·
---""''/#*()[]†‡§«»ˊ
ʃfʋw ſtthof
gʋwxyyz
ABCDEFGHI
JKLMNOPQRS
TUVWXYZ
ÆIJŁ&?
dd ke er ty ⌣ ꜱ

ITC ZAPF CHANCERY LIGHT ITALIC

abcdefghijklmnopqr
stuvwxyzABCDE
FGHIJKLMNOP
QRSTUVWXYZ
1234567890123 4567
890&$¢£%AÇÐEŁ
ØÆŒßaçdełøæœ:;,.
!¡?¿·""''---/#*()[]†‡§«»ˊ
ʃfʋw ſtthof
gkqʋwxyyyzT
ABCDEFGHIJKL
MNOPQRSTUVW
XYZ
ÆIJL
dd e er ty ⌣ ꜱ ?

TYPOGRAPHY	Herb Lubalin
DESIGN/CALLIGRAPHER	Hermann Zapf
TYPE SUPPLIER	Photo-Lettering, Inc.
CLIENT	International Typeface Corporation
PRINCIPAL TYPE	Zapf Chancery
DIMENSIONS	10¾ × 14¼" (27 × 36 cm)

Promotional/63

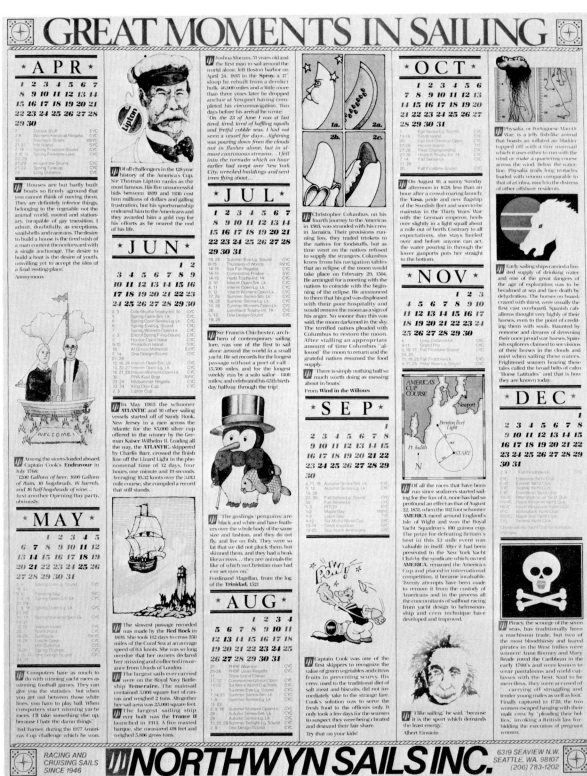

GREAT MOMENTS IN SAILING

TYPOGRAPHY/DESIGN	Warren Wilkins/Tommer Peterson
TYPE SUPPLIER	The Type Gallery, Inc.
STUDIO	Wilkins & Peterson Graphic Design
CLIENT	Northwyn Sails, Inc.
PRINCIPAL TYPE	Body: Zapf Book/Helvetica
	Heads: Neo-Berling Semibold
DIMENSIONS	18 × 23¼" (46 × 59 cm)

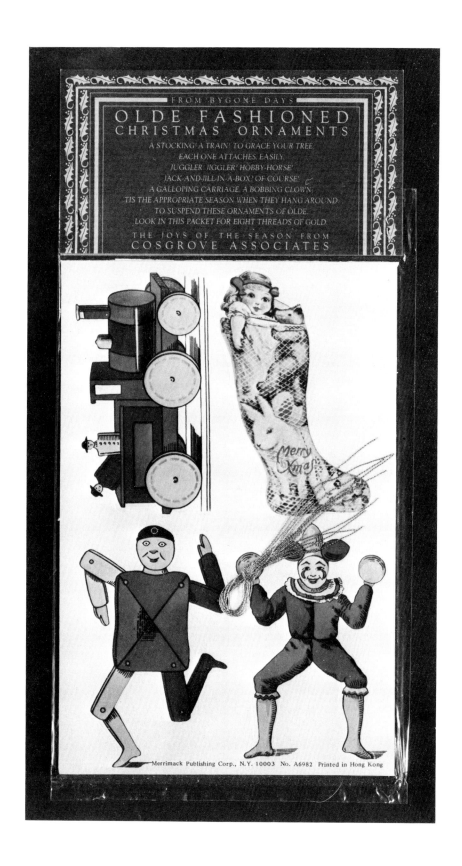

TYPOGRAPHY/DESIGN Jerry L. Cosgrove
TYPE SUPPLIER M. J. Baumwell Typography
STUDIO/CLIENT Cosgrove Associates, Inc.

PRINCIPAL TYPE Body: Goudy Old Style Italic
 Heads: Goudy Old Style
DIMENSIONS 5¾ × 11⅝" (15 × 30 cm)

come celebrate. we're expanding.

TYPOGRAPHY/DESIGN	Steven Fabrizio/Philip Gips
TYPE SUPPLIER	IGI
STUDIO/CLIENT	Gips + Balkind + Associates, Inc.
PRINCIPAL TYPE	Helvetica
DIMENSIONS	4¾ × 11¼ (12 × 29 cm)

TYPOGRAPHY Lea Pascoe
DESIGN Jann Church
TYPE SUPPLIER Orange County Typesetters
STUDIO Jann Church Advertising &
 Graphic Design, Inc.
CLIENT Avco Community Developers
PRINCIPAL TYPE Body: Palatino
 Heads: Palatino Bold
DIMENSIONS 8½ × 9½" (22 × 24 cm)

Advertising

Corporate Graphics
Newspaper and Magazine Display
Billboards
Car Cards

Our Fish Story starts with Signals from 600 miles up.

There's nothing new about a fisherman hoping for a little help from on high.

But when that help comes from a satellite, that's news.

Today, commercial fishermen are counting on—and getting—just that kind of help.

Signals from satellites 600 miles up, processed by a TRW electronic system, are helping fishermen find a homely little fish called the menhaden.

Meet the Menhaden.

If you're like most people, you wouldn't know a menhaden if it jumped in a boat with you.

Yet it represents nearly half the tonnage of all commercial fish caught in U.S. coastal waters every year—chiefly because of the high-quality fish meal and oil it yields.

That fish meal is used as a prime nutrient in a variety of animal feeds. And menhaden fish oil finds its way into products ranging from margarine to paints to lubricants.

Landsat and TRW: Going fishing with a photo from Outer Space.

Every day, these Landsat satellites send us volumes of information about how the earth looks. This information reaches us in the form of billions of electronic signals. Then a TRW system translates and enhances them—and turns them into super-clear color photos, packed with data about the earth and its waters.

For example, these space pictures can help reveal ocean features like sediment layers, depth, salinity and chlorophyll content. And where there's chlorophyll there's very likely to be phytoplankton— the basic food for the menhaden.

To a commercial fisherman, those photos can be worth their weight in gold—or fish.

They can save a whole fleet from wasting a lot of time looking in the wrong places for their catch.

And that means more fish to show for those long days at sea.

A COMPANY CALLED TRW

TYPOGRAPHY/DESIGN	William J. Square
TYPE SUPPLIER	Falcon Advertising Art, Inc.
AGENCY	Sapin & Tolle Advertising
CLIENT	TRW Inc. Corporate
PRINCIPAL TYPE	Body: Korinna Regular Heads: Neo-Arrow Roman
DIMENSIONS	7 × 10″ (18 × 25 cm)

Don't Fly Blind.

Fly Channel-Zip

Like any smart manufacturer, you don't run your business with your eyes closed. You make sure that everything that goes into your pants is of the highest quality.

That's why the Talon® Channel-Zip® zipper is the overwhelming choice of leading manufacturers of dress and casual pants.

Channel-Zip is fashionably slim and flexible, yet it's strong enough for the lifestyle of today's active man.

And it's backed by the zipper company with the highest degree of experience and expertise in the world.

So when you're looking for a reliable zipper, don't fly blind. Fly Channel-Zip.

Talon®
THE WORLD'S QUALITY ZIPPER

The Talon Channel-Zip zipper says a lot about the pants it's in.

TYPOGRAPHY	Jack Schier
DESIGN	Tom Wai-Shek/Peter Hirsch
TYPE SUPPLIER	Royal Composing Room, Inc.
AGENCY	DKG Advertising, Inc.
CLIENT	Talon Division, Textron, Inc.
PRINCIPAL TYPE	Body: Helvetica Light
	Heads: Times Roman

TYPOGRAPHY/DESIGN/
CALLIGRAPHER Richard Foy
STUDIO Communication Arts, Incorporated
CLIENT Boulder County Clothing Company

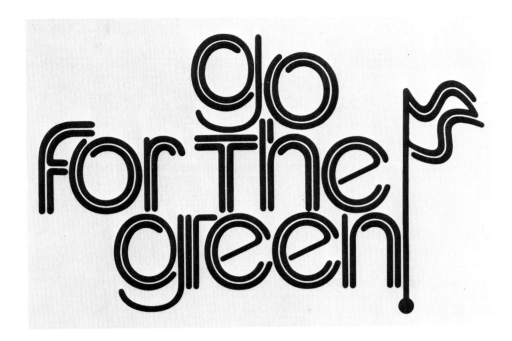

TYPOGRAPHY/DESIGN John Buchanan
TYPE SUPPLIER Letraset, USA
AGENCY Philip Office Associates, Inc.
CLIENT C & P Telephone

PRINCIPAL TYPE Uptight Neon

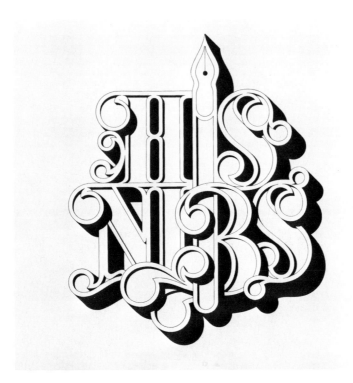

DESIGN/CALLIGRAPHER David Quay
STUDIO David Quay Lettering Designer
CLIENT Philip Poole

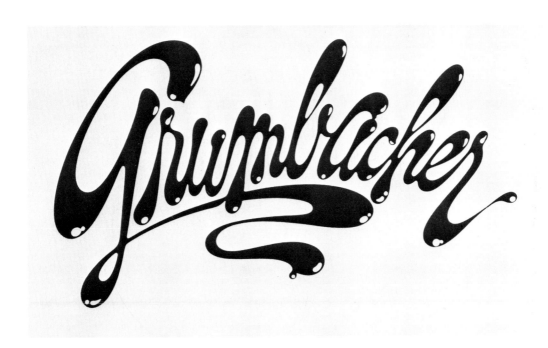

TYPOGRAPHY/DESIGN Herb Lubalin
CALLIGRAPHER Tom Carnase
STUDIO Herb Lubalin Associates Inc.
CLIENT Grumbacher/Lester Rossin

DIMENSIONS 8 × 10″ (20 × 25 cm) Advertising/73

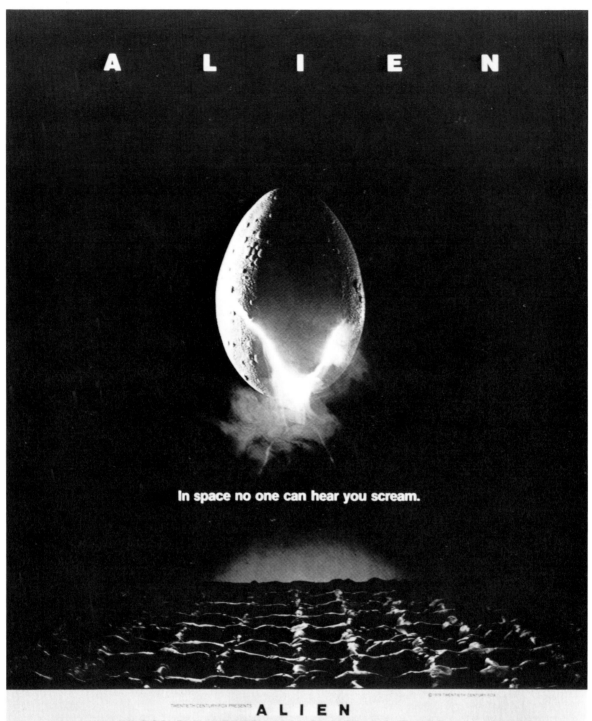

TYPOGRAPHY/DESIGN	Philip Gips
TYPE SUPPLIER	IGI
STUDIO	Gips + Balkind + Associates, Inc.
CLIENT	Frankfurt Communications/ Twentieth Century Fox
PRINCIPAL TYPE	Helvetica/Helvetica Bold
DIMENSIONS	30 × 40" (76 × 102 cm)

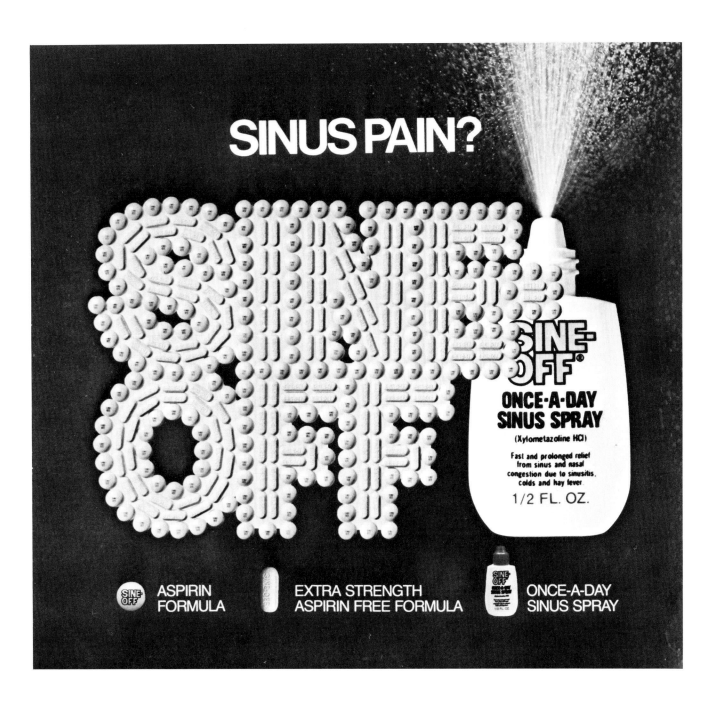

TYPOGRAPHY/DESIGN Mindy Yavorsky Glassman
TYPE SUPPLIER Progressive
CLIENT Menley & James Laboratories

DIMENSIONS 9⅝ × 9⅜″ (24 × 24 cm) Advertising/75

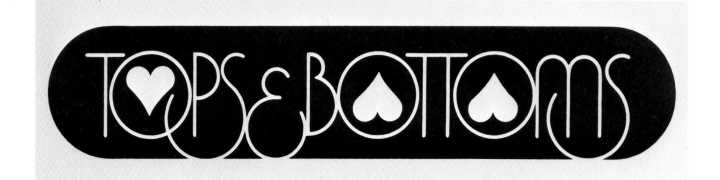

TYPOGRAPHY/DESIGN/
CALLIGRAPHER Victor Di Cristo
STUDIO Victor Di Cristo/Design
CLIENT Tops & Bottoms

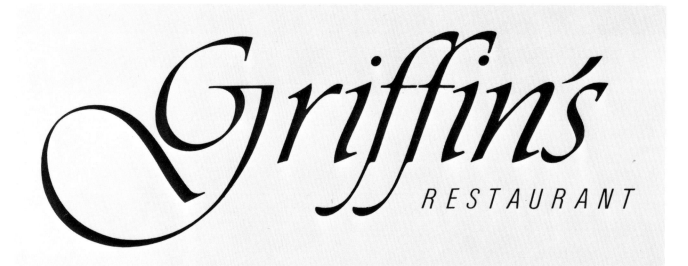

TYPOGRAPHY/DESIGN Peter Adam
AGENCY Gottschalk + Ash, Ltd., Toronto

CLIENT Griffin's Cafe/Restaurant

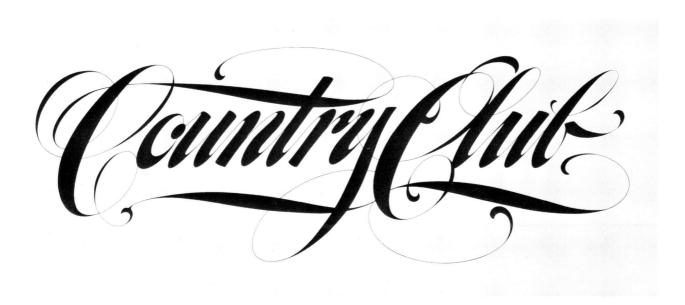

The New York Public Library

Astor, Lenox and Tilden Foundations

DESIGN Lou Fiorentino/Richard Moore
CALLIGRAPHER Hiroshi Taro Yamashita
STUDIO Muir Cornelius Moore
CLIENT New York Public Library
DIMENSIONS 11 × 14″ (28 × 36 cm)

DESIGN/CALLIGRAPHER Henry Beer
STUDIO Communication Arts, Incorporated
CLIENT Pinehurst Country Club

No guts, no glory.

It's well known that the tortoise can't make any progress unless he's willing to stick his neck out.

Likewise, when it comes to investments, if there's no risk, there's no reward.

Of course, sometimes the wisest course is to keep your neck in — as long as you remember that even the safest investments are subject to the eroding effects of inflation and taxes.

At Drexel Burnham Lambert, we believe your tolerance for risk should determine your investment strategy.

Our objective: to develop a strategy that produces the risk-reward ratio that's right for you.

To implement that strategy, we offer four basic investment approaches.

First, your individual brokerage account. Through your account executive, you have access to the expertise of over a thousand investment professionals. Research that's acclaimed by customers and competitors alike. Plus the whole range of investment products — domestic and foreign.

Second, the services of Drexel Burnham Lambert Investment Advisors.

Including both equity and fixed income management for individuals and corporate pension funds.

Third, Quantitative Portfolio Management. One of the longest-running applications of modern portfolio theory to actual investment management.

Fourth, Worldwide Investment Management. Because global diversification is one means of preserving real purchasing power. And we've been at it for years.

Drexel Burnham Lambert is a big international investment banking and brokerage firm. But not too big. For we know *your* future determines *our* future.

Drexel Burnham Lambert.

Before you stick your neck out, give us a call.

Drexel Burnham Lambert
The professionals who care.

TYPOGRAPHY/DESIGN	Mark Hogan
TYPE SUPPLIER	M. J. Baumwell Typography
AGENCY	Jim Johnston Advertising
CLIENT	Drexel Burnham Lambert
PRINCIPAL TYPE	Bookman Medium
DIMENSIONS	15¼ × 21½″ (39 × 55 cm)

TYPOGRAPHY Chuck Painter
DESIGN Albert Wong
TYPOGRAPHIC SUPPLIER Pola/Graphics Ltd.
CALLIGRAPHER Martin Jackson
STUDIO/CLIENT Painter + Green Artists Ltd.

PRINCIPAL TYPE ITC Garamond Book Condensed Italic
DIMENSIONS 9½ × 37″ (24 × 94 cm)

INTRODUCING
MARSTON'S MILL

Introducing Marston's Mill.
An industrious little building
from America's early heritage.
With its waterwheel and
millpond, set simply into
the countryside.
Our mill itself exists,
not in fact, but in
memory. A composite
of the hundreds of grist
and feed and woolen
mills that were a New
England institution.

The mill was chosen
as our trademark
because it repre
sents, to us, some
important values.
Values that well
served these early
mill works. Quality,
dependability and
service. Old
fashioned, and
often overlooked
ingredients of
success.

OUR
NEW
COMPANY.

We would like to
introduce you to
MARSTON'S MILL, the newest
unit of the Giftware Group.

MARSTON'S MILL makes
brand new bath products
in the old-fashioned way.
Our soaps are
produced from the finest
natural ingredients.
We utilize the
French milling
process . . . a lengthy,
but important
step toward insuring uniform
smoothness and hardness.
The packaging and presentation
is the freshest, newest look in the
marketplace. By combining
traditional methods and values
with current technology and fashion,
we've created a brand new,
old fashioned company.
MARSTON'S MILL.
Fine soaps since 1978!

The success of
Marston's Mill depends
on our adherence to
these values. So the
mill is more than a
symbol. To us it's a
constant reminder. To
you, an assurance of
quality and service.

MARSTON'S MILL

ONLY THE FINEST CONTEMPORARY SOAPS IN THE COUNTRY TRADITION.

TYPOGRAPHY/DESIGN/
CALLIGRAPHER William Thauer
TYPE SUPPLIER Typographic House, Boston
CLIENT Marston's Mill

PRINCIPAL TYPE Benguiat
DIMENSIONS 8½ × 11" (22 × 28 cm)

ENGLISH SPOKE.

Harrods is conveniently situated at the centre of a smart shopping district. It has a reputation for excellent service.

The staff are both helpful and courteous and several of them speak quite good English.

There are flights here twice a week on Aerolineas Argentinas 747's. (That's from Heathrow alone: other European capitals are equally well served.) The drive in from the airport takes about an hour, giving you the chance to pick up a few ideas about Buenos Aires.

Your taxi driver, for instance, may try to stun you with his Fangio impressions, while Buenos Aires shows off by changing her architectural style every half mile. Your hotel will impress much in the manner of Harrods.

Should you choose to patronise the bar you'll find English being widely spoken here. Argentina is in the process of being discovered both by travellers seeking an extraordinary holiday and businessmen finding a sound area for overseas investment.

It's not difficult, though, to escape the sound of the Anglo-Saxon tongue. If you can get a taxi to stop long enough for you to get in, take a trip out to the La Boca district of Buenos Aires.

La Boca is where the tango is said to have been invented. When things hot up, which is usually around one in the morning, you can hear La Boca from half a mile away. In La Boca the steaks are literally an inch thick. (Go easy on the wine, incidentally. That fragrant bouquet hides a kick like a mule.) La Boca is not the place for a teetotal vegetarian.

Buenos Aires is the capital of a country the size of Western Europe with both resources and potential. A country that stretches from the South Pole to the Tropics.

Buenos Aires is linked to the rest of the country and South America by Aerolineas Argentinas' internal flight network. (All ticketing for flights within the South American continent may be done in London.) While Aerolineas Argentinas flights to North America and Europe complete the picture.

Obviously, though, the story does not stop here. For more facts about Argentina just clip the coupon.

Please send me a little information about the eighth largest country in the world.

Name
Address

✈ AEROLINEAS ARGENTINAS

TYPOGRAPHY	Robbie Sparks
DESIGN	Paul Simblett
TYPE SUPPLIER	Conways'
AGENCY	Marsteller, London
CLIENT	Aerolineas Argentinas
PRINCIPAL TYPE	Body: Avant Garde Light Heads: Benguiat Medium

TYPOGRAPHY/DESIGN Beau Gardner/Tom Guerrieri
TYPE SUPPLIER/CLIENT Barton Press
STUDIO Beau Gardner Associates Inc.

PRINCIPAL TYPE Helvetica
DIMENSIONS 10⅛ × 9″ (26 × 23 cm)

TYPOGRAPHY/DESIGN	Ernst Roch
STUDIO	Roch Design
CLIENT	Imasco Limitée
DIMENSIONS	23¼ × 33″ (59 × 84 cm)

Advertising/83

ONLY ONE BRUSHMAKER GUARANTEES ITS BRUSHES IN WRITING.

LIMITED WARRANTY

M. Grumbacher, Inc., 460 West 34th Street, New York, New York 10001, warrants to the original consumer purchaser for a period of one year from the date of original purchase that the artist brushes it manufactures will be free of defects in material and workmanship. Any implied warranties, including that of merchantability, are also limited to one year from the date of original purchase.

If an artist brush develops such defect within this period, it will be replaced, provided it is returned, postage prepaid to M. Grumbacher, Inc., Guaranty Center, 460 West 34th Street, New York, New York 10001. The above remedy is exclusive. M. Grumbacher, Inc. will not be liable for any incidental or consequential damages.

This warranty gives you specific legal rights, and you may also have other rights which vary from state to state. Some states do not allow limitations on how long an implied warranty lasts, or the exclusion or limitation of incidental or consequential damages, so the above limitations or exclusions may not apply to you.

At Grumbacher we make every brush by hand.

We know what we put into it. We know what you'll get out of it.

So we offer the industry's only written brush guarantee.

What puts a Grumbacher brush in a class by itself? Little things. Like our choice of hair.

Longer hair, better performance.

We buy longer hair than we have to. Then we bury as much as half the length inside the ferrule where you'll never see it.

This gives the part you do see more strength, more snap, more resilience.

Special cement.

We're just as fussy about cement. Because poor or improperly applied cement in the ferrule is the major cause of hair loss.

Different types of hair react differently to cement. What's right for red sable is wrong for bristle. What's perfect for ox hair may be poor for camel hair.

So we developed a special formula for each. And special equipment to apply it, so there's never too much or too little.

Seamless ferrules.

We could save a few cents by using ferrules with seams. But seams have a way of pulling apart with use. Paint and thinner can get up inside the ferrule. So we use seamless ferrules and gladly pay the extra price.

Birch handles.

For handles, we shape specially selected New England birch. Why birch? Because it provides the right relationship of weight to mass, the best balance in your hand.

Each handle is carefully sealed to prevent cracking, and double-lacquered for long life.

Better joining.

Like others, we join the handle and ferrule by crimping. But we go a step further. We cement the handle to the ferrule as well. You get a handle that starts secure and stays secure.

12 quality checks.

Each of the eleven craftsmen who works on a brush inspects it and may reject it for the slightest flaw. Then our official inspector makes his own examination, aided by a ten-power magnifier.

The next time you're tempted to buy a cheap "look alike," remember—only Grumbacher goes to so many steps to assure quality. And only Grumbacher backs its brushes in writing.

Is anything else worth the risk?

GRUMBACHER
See what our art can do for yours.

TYPOGRAPHY/DESIGN	Herb Lubalin
TYPE SUPPLIER	M. J. Baumwell Typographers
STUDIO	Herb Lubalin Associates Inc.
CLIENT	Grumbacher/Lester Rossin
PRINCIPAL TYPE	Benguiat
DIMENSIONS	19 × 12½″ (48 × 32 cm)

GIAMBATTISTA BODONI, whose works shed lustre on the typographic arts, was born in Italy in 1740, and learned the printing trade in the small plant of his father. At age eighteen he entered a printing house maintained by the Roman Catholic Church. This historic plant had its own typefoundry, and was the first to issue a type specimen book.

GIAMBATTISTA
BODONI

Bodoni was greatly interested in typefounding and through great determination became an expert matrix maker. But always the thing he was most intent to do was to print beautifully. Bodoni developed lofty ideals and he visualized anew the intrinsic beauty of typography. He introduced a distinct and beautiful style into his types which was the forerunner of all modern faces, changing the typographic standard of taste entirely. His style is always chaste, relying upon suitable spacing, good proportions and proper margins, rather than upon the use of the decorative effects then in vogue.

He had conceived the idea of making Roman type faces quite different from the faces which were then in use. One of the changes which Bodoni introduced into the forms of his Roman letters was in the serifs. Those of the capitals he reduced to single sharp lines of about the same weight as the thin strokes of the letters, while the serifs of his lower-case characters are raised to an almost horizontal position at right angles with the upright strokes of the letter. The new design was called Modern Roman. Oldstyle Roman letters attempted to reproduce the effect of calligraphy, whereas the Modern Romans are undisguisedly the work of steel engravers—sharp, clear, clean cut and precise.

No printer or typefounder has exercised a greater influence on the style of printing or the form of all Roman letters than Bodoni. So great was the beauty of his type faces, that it was not long before other old style faces disappeared entirely from type specimen books. The open pages with generous margins and the beauty of his type faces make the old volumes printed by him a pleasure to read. His works show that Bodoni never printed anything in an indifferent manner.

BODONI

ABCDEFGHIJKLMNOPQRSTUVWXYZ
abcdefghijklmnopqrstuvwxyz 1234567890

One in a series of advertisements commemorating type face designers present and past

RyderTypes, Inc.
Advertising Typographers

500 North Dearborn
Chicago, Illinois 60610

312 467 7117

TYPOGRAPHY	Al Garzotto
DESIGN	Arthur Modjeski
PRINCIPAL TYPE	Body: Bodoni Book
	Heads: Bodoni
DIMENSIONS	8½ × 11″ (22 × 28 cm)

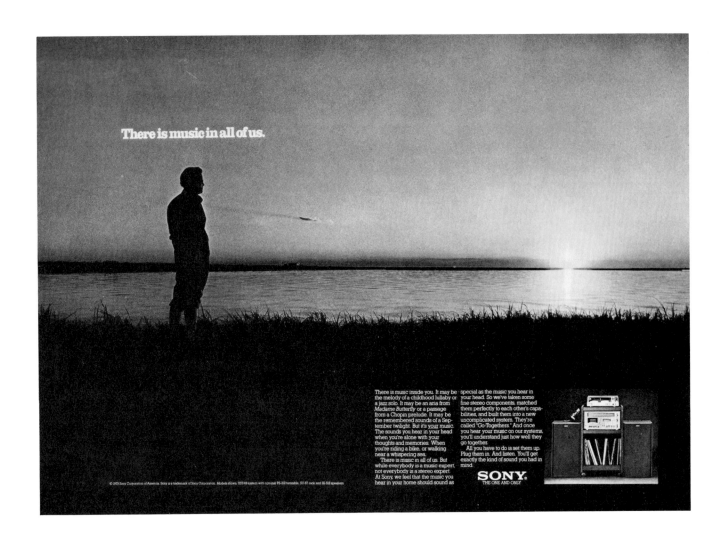

There is music in all of us.

There is music inside you. It may be the melody of a childhood lullaby or a jazz solo. It may be an aria from *Madame Butterfly* or a passage from a Chopin prelude. It may be the remembered sounds of a September twilight. But it's your music. The sounds you hear in your head when you're alone with your thoughts and memories. When you're riding a bike, or walking near a whispering sea.

There is music in all of us. But while everybody is a music expert, not everybody is a stereo expert. At Sony, we feel that the music you hear in your home should sound as special as the music you hear in your head. So we've taken some fine stereo components, matched them perfectly to each other's capabilities, and built them into a new uncomplicated system. They're called "Go-Togethers." And once you hear your music on our systems, you'll understand just how well they go together.

All you have to do is set them up. Plug them in. And listen. You'll get exactly the kind of sound you had in mind.

SONY.
THE ONE AND ONLY

© 1973 Sony Corporation of America. Sony is a trademark of Sony Corporation. Models shown: HST-69 system with optional PS-333 turntable, SU-67 rack and SS-502 speakers.

TYPOGRAPHY	Mari Fox
DESIGN	Henry Holtzman
TYPE SUPPLIER	Royal Composing Room/Techni-Process
AGENCY	McCann-Erickson, Inc.
CLIENT	Sony Corporation
PRINCIPAL TYPE	Body: Sony Rockwell Light
	Heads: Haas Clarendon Bold
DIMENSIONS	17 3/16 × 11¾″ (44 × 30 cm)

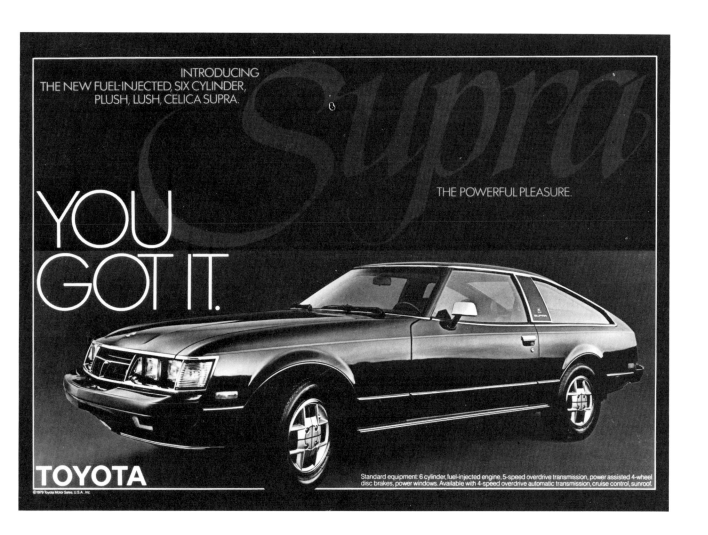

INTRODUCING
THE NEW FUEL-INJECTED, SIX CYLINDER,
PLUSH, LUSH, CELICA SUPRA.

THE POWERFUL PLEASURE.

YOU GOT IT.

TOYOTA

©1979 Toyota Motor Sales, U.S.A., Inc.

Standard equipment: 6 cylinder, fuel-injected engine, 5-speed overdrive transmission, power assisted 4-wheel disc brakes, power windows. Available with 4-speed overdrive automatic transmission, cruise control, sunroof.

TYPOGRAPHY/DESIGN	Deborah Lyons/Gordon Price
TYPE SUPPLIER	Photo-Lettering, Inc.
CALLIGRAPHER	Hal Fiedler
AGENCY	Dancer · Fitzgerald · Sample, Inc.
CLIENT	Toyota Motor Sales
PRINCIPAL TYPE	Body: Helvetica Regular
	Heads: Futura
DIMENSIONS	17¼ × 11¾" (44 × 29.8 cm)

Advertising/87

TYPOGRAPHY/DESIGN	Richard Wehrman
TYPE SUPPLIER	Setronics Limited/Letraset USA
STUDIO	Bob Wright Studio, Inc.
CLIENT	Vern Iuppa/Marie Tedeschi
PRINCIPAL TYPE	Garamond Italic/Chippendale
DIMENSIONS	11 × 11" (28 × 28 cm)

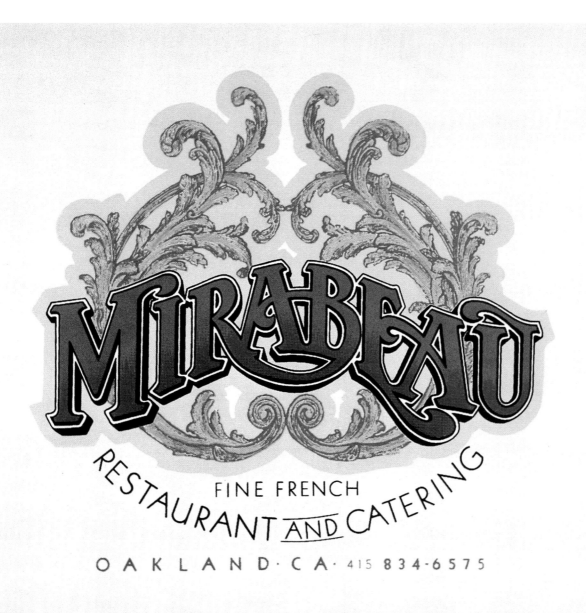

FINE FRENCH

RESTAURANT AND CATERING

OAKLAND·CA· 415 834-6575

DESIGN/CALLIGRAPHER Thomas Morris
STUDIO Sharpshooter Studios
CLIENT Mirabeau Restaurant and Catering

DIMENSIONS 8 × 10″ (20 × 25 cm) Advertising/89

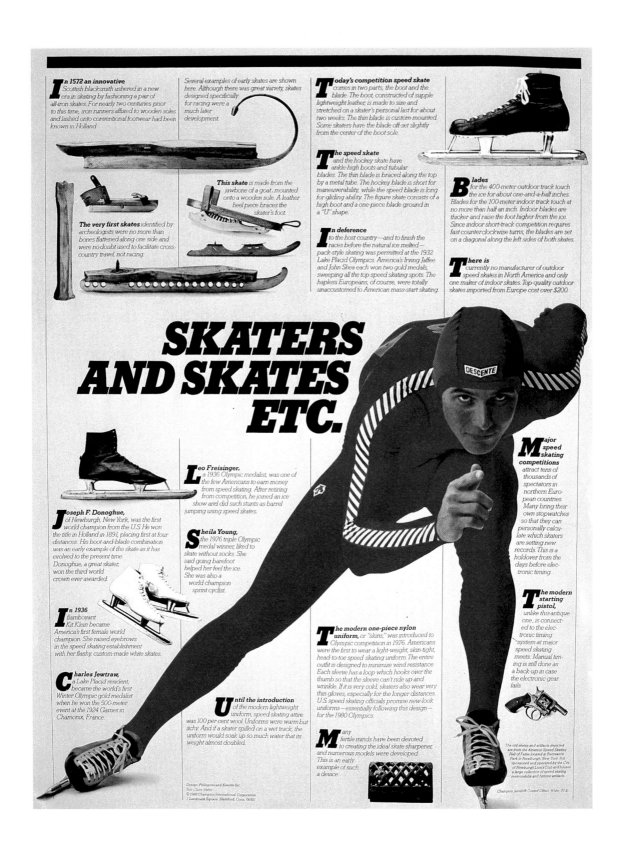

TYPOGRAPHY/DESIGN David Kaestle/Ted Williams
TYPE SUPPLIER TGI
STUDIO Pellegrini and Kaestle, Inc.
CLIENT Champion International Corp.

PRINCIPAL TYPE Body: Stymie Light
 Heads: Stymie Bold

 DIMENSIONS 18 × 24" (46 × 61 cm)

Very Outstanding *Alphabets*

Here are the ABC's in Thermography by Cameo: It looks like fine engraving. It feels like fine engraving. It doesn't cost anything like fine engraving. Simple but elegant business cards, letterheads and envelopes. Thermography raises your image to new heights. It's permanent. Can't rub off. You can use it to emphasize a single letter or illustration, or for an entire piece, or any which way. It gives a depth of tone, a glow, a radiance, that ordinary printing can't touch. In short, Thermography by Cameo is very outstanding. And that's the XYZ of it.

CAMEO
"We're Very Outstanding"

TYPOGRAPHY/DESIGN/ CALLIGRAPHER	Ted Bertz
TYPE SUPPLIER	Eastern Typesetting Co.
STUDIO	Ted Bertz/Design Inc.
CLIENT	Cameo Printing Co.
PRINCIPAL TYPE	Body: Cheltenham Book Heads: Cursive
DIMENSIONS	8¾ × 11" (22 × 28 cm)

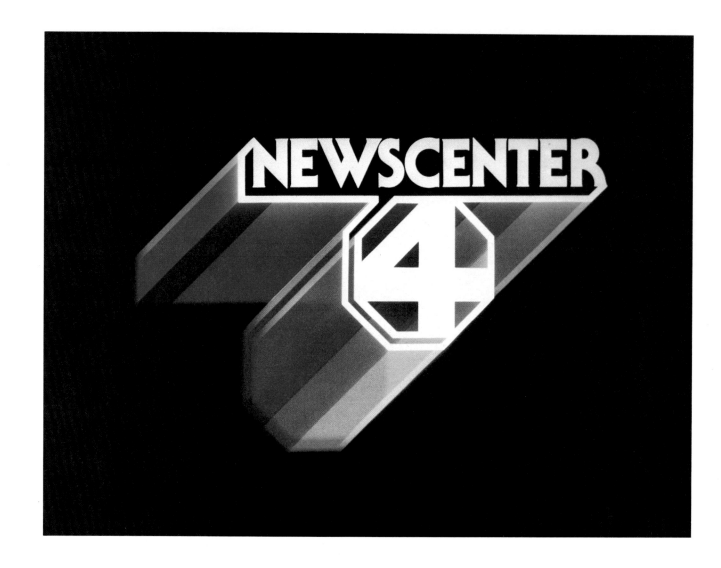

DESIGN Beverly Littlewood/Gary E. Teixeira
STUDIO NBC/TV Graphic Design
CLIENT News Center 4

PRINCIPAL TYPE Serif Gothic
DIMENSIONS 11 × 11″ (28 × 28 cm)

TYPOGRAPHY Michael Gericke
DESIGN Richard Foy
STUDIO Communication Arts, Incorporated
CLIENT Chesapeake Bay Company

PRINCIPAL TYPE Goudy Multicase/Bookman
DIMENSIONS 72 × 32″ (183 × 81 cm)

Advertising/93

DESIGN Alan Peckolick
TYPE SUPPLIER/STUDIO Herb Lubalin Associates Inc.
CLIENT Warner Communications
DIMENSIONS 9 × 8″ (23 × 20 cm)

TYPOGRAPHY/DESIGN Steven Rousso
CALLIGRAPHER Harry Westbrook
STUDIO Garrett/Lewis/Johnson
CLIENT Dennis Kruse

TYPOGRAPHY/DESIGN	Arthur Beckenstein
TYPE SUPPLIER	Photo-Lettering, Inc.
STUDIO	Arthur Beckenstein
CLIENT	James Kirkwood
PRINCIPAL TYPE	West Behemoth Clarendon 11/ West Behemoth Condensed 11

TYPOGRAPHY/DESIGN	Michael Fountain
CALLIGRAPHER	Michael Doret
AGENCY	Rumrill-Hoyt Inc.
CLIENT	Remington Arms Co.
DIMENSIONS	8½ × 14″ (22 × 36 cm)

Editorial

Magazines
Newspapers
Books
Company Publications
Special Editions

Aa Bb Cc Dd Ee Ff Gg Hh Ii Jj Kk Ll Mm Nn Oo Pp Qq Rr Ss Tt Uu Vv Ww Xx Yy Zz 1234567890 & Æ Œ $ ¢ £ %!? () []

UPPER AND LOWER CASE THE INTERNATIONAL JOURNAL OF TYPOGRAPHICS PUBLISHED BY INTERNATIONAL TYPEFACE CORPORATION VOLUME SIX, NUMBER ONE, MAR. 1979

Jim Spanfeller's Fantastic Airplane

What has a fabulous drawing of a fabulous airplane got to do with the state of the typographic arts? The answer is fairly simple. In recent issues of U&lc we have attempted to create exciting formats, reproduced in color, to display as effectively as we know how, our latest featured typefaces. The devices we have employed stray considerably from the purely typographic. In one case we resurrected some old posters to show how they could look—and possibly be improved—with the use of contemporary ITC typefaces. Our issue on ITC Cheltenham included significant commentary on typography by famous literary figures. Our attempt there was to indicate that some very important people, not associated with letterforms, had written astutely on the subject. At the same time we tried to show that good writing and good typography are highly synergistic. Our last issue, featuring the ITC Benguiat Condensed series, sent us scurrying through every page of an unabridged dictionary to select what we thought were the eight most exciting looking words in the English language when set in ITC Benguiat Condensed. All of which brings us back to the answer to the long forgotten question at the be- ginning of this article.

CONTINUED ON PAGE 36

TYPOGRAPHY/DESIGN	Herb Lubalin
TYPE SUPPLIER	Photo-Lettering, Inc.
STUDIO	Herb Lubalin Associates Inc.
CLIENT	International Typeface Corporation
PRINCIPAL TYPE	Clearface (ITC)
DIMENSIONS	22 × 14½" (56 × 37 cm)

U&lc.

Aa Bb Cc Dd Ee Ff Gg Hh Ii Jj Kk Ll Mm Nn Oo Pp Qq Rr Ss Tt Uu Vv Ww Xx Yy Zz 1234567890 & Æ Œ $ ¢ £ %!?()[]

UPPER AND LOWER CASE. THE INTERNATIONAL JOURNAL OF TYPOGRAPHICS PUBLISHED BY INTERNATIONAL TYPEFACE CORPORATION. VOLUME SIX, NUMBER TWO, JUNE 1979

PETER BEARD'S DIARY

BY CAROL DIGRAPPA

I first saw the remains of Peter Beard's diaries in November 1977 at the International Center of Photography. Earlier that year, over twenty years of diaries had been destroyed in a fire that razed Beard's Montauk windmill residence. Only two books survived. The 1976 **Bicentennial Diary**, which was at Meriden Gravure on the night of the fire, hung on the walls in lithographs—a colorful and portentous frieze in a bright white room. **The Elephant Diary**, filled with photographs dating from 1971 to 1976, had been with Beard the night of the fire and now lay open in a black box in the center of the room. The casket also held the soggy pile of burned books—ashes, mold and all.

Marvin Israel designed the show of diaries and dying elephants (from Beard's book **The End of the Game**) as a conceptual installation. To give the viewer the feeling of African imbalance, photographs of starved elephants, disintegrating carcasses, and ravaged land were theatrically lighted in the dark. Elephant dung, animal skulls, stress boxes jammed with progress reports from Kenya Colony, and jungle sounds carried out the themes of overpopulation, stress and destruction of habitat.

The elephants stood out as a metaphor for men. In contrast to the rest of the museum, the diary room seemed modern and light—an embellishment of the theme. The pages overlapped on the wall in a detailed bas-relief which, like death itself, seduced and repelled simultaneously.

After seeing pictures of so many rotting carcasses, the diaries conjured up a dream of the primeval forest—of a dense chaos. On each page, a wild landscape of "piddling trivia and absurdities" grew like a fungus. Each image was woven into another, blending and layering arcane truths and media nonsense until open space seemed as rare as in the forest, as meaningful as silence. Almost as if the diaries had designed themselves, they reflected a strange order in a complex growth of visions.

CONTINUED ON PAGE 4

TYPOGRAPHY/DESIGN	Herb Lubalin
TYPE SUPPLIER	Photo-Lettering, Inc.
STUDIO	Herb Lubalin Associates Inc.
CLIENT	International Typeface Corporation
PRINCIPAL TYPE	Zapf Chancery
DIMENSIONS	22 × 14½" (56 × 37 cm)

Editorial/99

AaBbCcDdEeFfGgHhIiJjKkLlMmNnOoPp QqRrSsTtUuVvWwXxYyZz1234567890&ÆŒ$¢£%!?()[]

UPPER AND LOWER CASE, THE INTERNATIONAL JOURNAL OF TYPOGRAPHICS PUBLISHED BY INTERNATIONAL TYPEFACE CORPORATION, VOLUME SIX, NUMBER THREE, SEPT. 1979

The marvelous typographic portrait of Pablo Picasso was sent to us by Paul Siemsen in response to our "Put your best face forward" request. We thought so much of the design that we decided to use it as our cover for this issue. The idea was conceived, designed, researched, and written by Siemsen as a promotion poster for The Graphic Corporation, a studio-print house in Des Moines, Iowa. It uses four different size/weight combinations of ITC Korinna. It is now available in poster form, silk-screened on rag paper, and is signed by the designer. If you're interested, write to Paul Siemsen, The Word/Form Corporation, 130 Main Street, Box 508, Ames, Iowa 50010. Thanks, Paul, for certainly putting your best face forward.

When the **name** Picasso falls up**on the eye**, a portrait of a legend comes to m**ind. It'**s the legend in the world of art which surrounds **a** man who possessed and expressed many of the highest ide**als of mankind.** The popular **leg**end is of the outward attributes: seclu**sion and gregariou**sness; wealth **and** love; abun**dance of** works and extr**aordinar**y **versatility in all facets** of his **field. It** has been estimated that Pica**sso creat**ed **over fifty thousand works of art. Pab-lo Ruiz** Picasso was born into a family of art, so **he naturally had a very early beginning in his** creations. His life was long, ninety-one **years, but when we do** the arithmetic we still find **that** he **av**eraged throughout his creative years al**most two pieces of art per day. Considering the physical** size and the conceptual scope of many of **his works,** these numbers be**speak a remarkable feat. How is it** that a man could be so one-pointed and invent**ive that he would become, as one author describes him, "the** most prolific artist of all times?" Picasso's own word**s may reveal the answer: "Painting is stronger than I am; also, "**painting makes me do what it wants.**" Another of the component**s of the **popular legend is that of** his departure from tradition. Picasso is known by many as hav**ing been instrumental in founding and energiz-ing** two new movements in art, cubism and surreal**ism; and to have inspir**ed other m**ovements including ab-**stract **art and** pop art. His departure into cu**bism, which has beco**me per**haps his best known realm, was met at the** time with ridicule and contempt. Th**e general attitude of those** who saw **this new trend was, at** be**st**, closer to endurement than to endearment. A v**ery few** had any **awa**re**ne**ss that in **Picasso painting was giv**-ing birth to truly **s**ignificant modes of seeing and **expression. These few, a**nd Pi**ca**sso himself, might have **argued that** his seemingly **radical** forms were logical outcomes o**r e**xtensions of the traditions of **painting** thus far, or at least, **of the sp**ir**it** of painting. That sa**me** unbounded energy of **a**r**t** that had explored so many obvious **and s**u**b**tle ways of s**ee**ing **was, in this** twentieth-century Spaniard, continuing its ex**p**loration. The wor**ld h**as indeed marveled **that so** much of that e**ner**gy **was con**-centrated through the eye-hand of this one man. Those who **hav**e known Picasso and **have** written of him beg**in to reveal** the inner, mystical legend when they independently asc**ri**be this superconductivity to hi**s uncea**sing wonderment-a won-derment born of innocence and openness that had no need to look through the tinted **glasses of dogma. Indeed, as** his own cubist movement became intellec**tu**ally structured and dogmatic, he left it**s mainstream. In doing this,** he kept himself in the m**a**in evolutionary stream of art itself, which adheres to prin**ciples of a more general** and interaccommodative nature. Picasso w**as thus** free to draw upon the principl**es he had discovered in** several specific modes of painting to achieve a**n** even more comprehensive vision. **One n**eed**s to be careful** not to think that he mixed some of this style and some of that to achieve something **new.** His **art grew from** within and manifested itself in the appearance of **m**ixture. He elaborated, "**Art is not the application** of a canon of beauty, but what the instin**ct a**nd the brain can conceive inde**penden**tly **of that can-**on. When you love a woman you don**'t t**ake instruments to measure her b**ody, you love her** with your desires." His ability to **cr**eate independently of the numerou**s canons of beauty** was witnessed by Gertrude Stein, **o**ne of his earliest patron**s, who said, "He alone among** painters did not set himself the **pr**oblem of expressing trut**hs** whi**ch all the wo**r**ld can** see, but the truth which only he can **se**e." This internal truth mu**st ha**ve b**een operative when** Picasso painted his well-known portr**a**it of Gertrude Stein, for without **something of an inner vis**io**n** his reflections on the portrait would **s**ee**m** absolutely baffling. As the story goes, he **made** M**iss** Stein sit eighty times for the portrait, and **then** he wiped out her face and subst**ituted a face with** mask-like qualities. There were criticisms which **he** dismissed with "Every**b**ody thinks **that the port**r**ait is not** like her, but never mind, in the end she will look like the portrait." Such a statement **might seem imp**ert**inent, b**u**t** it is hard to ques-tion his integrity, for his commitment to his work was absolute. Every work was bor**n of desire and in deep co**ncentration. Every wo**rk was** also born living its own life. A painting or sculpture or lithograph or whatever, would begin **in impulse, in vague i**dea, **in sp**irit. Then as art "**made him do what** it wanted" it would evolve through the brush of its creator. Each stroke and each picture was **an end, a breathing** unive**rse itself. Picasso seldom **sign**ed his works a**nd never named them. He also customarily refused to explain them. It is perceived that such acts might have **put too definitive b**oundaries on the pieces, limiting **the potentia**l that con-tinues to exist within them. A father gives his child his own autonomy, never acknowledging **the moment he be**comes adult **a**nd never say**ing** to him this **is the** k**i**nd of person you are or that is the kind of influence you have, because the child may become much more or may be seen to be much more. For similar reasons, **on**e hesitates to wr**ite** of the legend of **Pablo** Picasso, i.e. for fear of severely limiting its fullness. Yet, even as the legend itself is found within the depths of the viewer's consciousne**ss, s**o are these words found look**ing** out of a pie**ce of paper.**

© THE WORD-FORM CORPORATION, 1978

TYPOGRAPHY/DESIGN	Herb Lubalin
TYPE SUPPLIER	Photo-Lettering, Inc.
STUDIO	Herb Lubalin Associates Inc.
CLIENT	International Typeface Corporation
PRINCIPAL TYPE	Benguiat
DIMENSIONS	22 × 14½" (56 × 37 cm)

Aa Bb Cc Dd Ee Ff Gg Hh Ii Jj Kk Ll Mm Nn Oo Pp Qq Rr Ss Tt Uu Vv Ww Xx Yy Zz 1234567890 & ÆŒ $¢£%!?()[]

UPPER AND LOWER CASE. THE INTERNATIONAL JOURNAL OF TYPOGRAPHICS PUBLISHED BY INTERNATIONAL TYPEFACE CORPORATION. VOLUME SIX, NUMBER FOUR. DEC. 1979

MECHANIMALS

I LOVE MACHINERY. I LOVE DRAWINGS, PHOTOGRAPHS AND DIAGRAMS OF MACHINERY. PARTICULARLY DIAGRAMS. THEY LOOK IMPORTANT. THEY DEMAND RESPECT AND THEY INSPIRE CONFIDENCE. HOW DARE ANYONE DOUBT THAT THOSE DOTTED LINES, THOSE BEAUTIFUL ARROWS AND THE MYSTICALLY PLACED LITTLE UPPERCASE LETTERS INDICATE SOMETHING OF GREAT BUT OBSCURE SIGNIFICANCE? ✳ THE BLUEPRINT ALSO IS A FORM OF VISUAL TYRANNY. IT IS YET ANOTHER KIND OF ICON TO BE REVERED BY THE MECHANICALLY SOPHISTICATED, AND LOOKED UPON WITH AWE BY THE MECHANICALLY ILLITERATE, SUCH AS MYSELF. ✳ THESE DRAWINGS ARE MY SEMI-RESPECTFUL HOMAGE TO ALL THE MODEL AIRPLANES THAT I ALMOST COMPLETED, EVERY PRINTED-IN-JAPAN SET OF INSTRUCTIONS THAT LED ME ASTRAY. BUT MOST OF ALL TO THOSE PASSIONATELY STERILE DRAWINGS AND ENGRAVINGS THAT GRACED THE PAGES OF THE DICTIONARIES AND ENCYCLOPEDIAS OF MY YOUTH. ✳ AS FAR AS I AM CONCERNED, A STEAM-DRIVEN CHAMELEON, A TRACTOR-TREADED RHINOCEROS, A DIESEL-DRIVEN GUPPY, AND A PROPELLER-POWERED BASS ARE AT LEAST AS VALID AS ALL THAT OTHER STUFF. THESE, TOO, ARE REAL. IF YOU DON'T BELIEVE HOW REAL THEY REALLY ARE, JUST, FOLLOW THE DOTTED LINES AND ARROWS AND THE VERBAL DESCRIPTIONS ON THESE PAGES.

CONTINUED ON PAGE 4

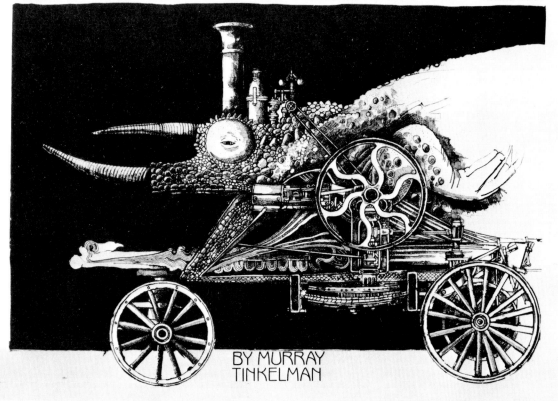

BY MURRAY TINKELMAN

TYPOGRAPHY/DESIGN	Herb Lubalin
TYPE SUPPLIER	Photo-Lettering, Inc.
STUDIO	Herb Lubalin Asociates Inc.
CLIENT	International Typeface Corporation
PRINCIPAL TYPE	Novarese
DIMENSIONS	22 × 14½" (56 × 37 cm)

Editorial/101

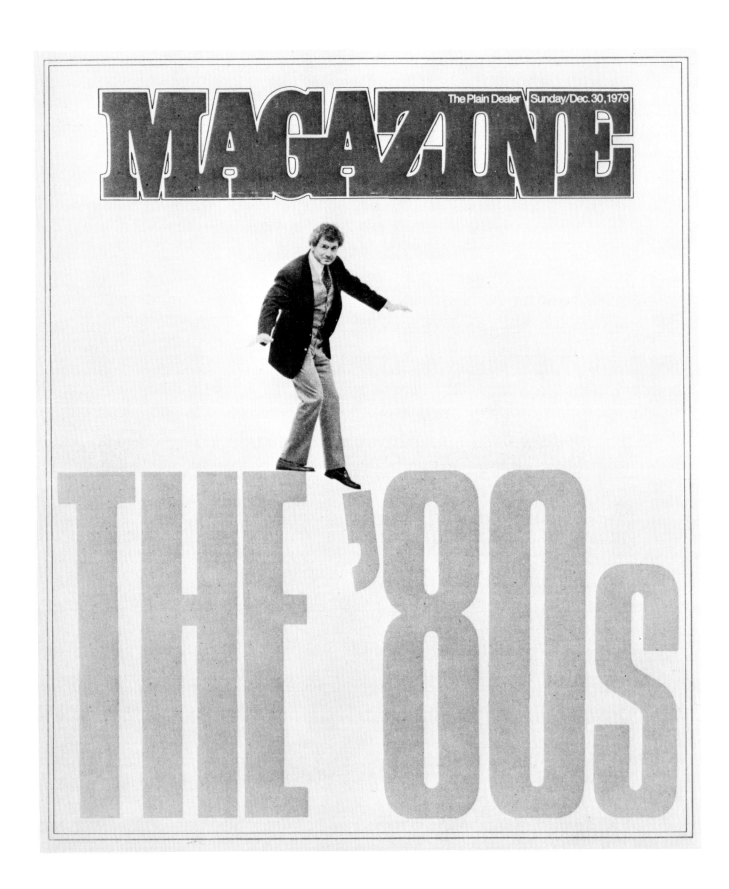

TYPOGRAPHY/DESIGN Greg Paul
TYPE SUPPLIER Letraset
CLIENT The Plain Dealer Magazine

PRINCIPAL TYPE Compacta
DIMENSIONS 10¼ × 12¼″ (26 × 31 cm)

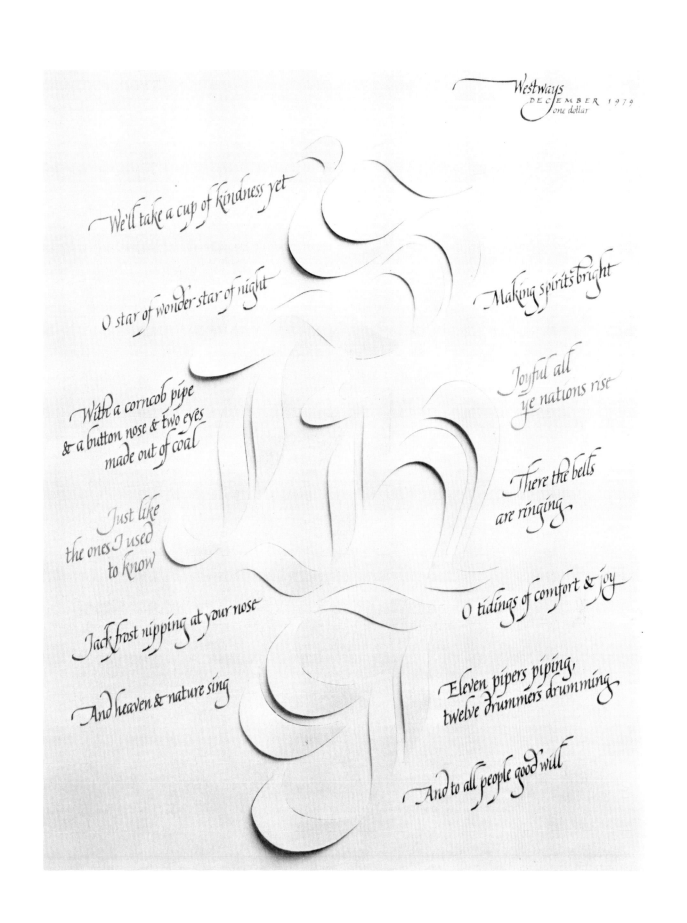

We'll take a cup of kindness yet

O star of wonder star of night

Making spirits bright

With a corncob pipe
& a button nose & two eyes
made out of coal

Joyful all
ye nations rise

Just like
the ones I used
to know

There the bells
are ringing

Jack frost nipping at your nose

O tidings of comfort & joy

And heaven & nature sing

Eleven pipers piping,
twelve drummers drumming

And to all people good will

Westways
DECEMBER 1979
one dollar

TYPOGRAPHY/CALLIGRAPHER Morris Zaslavsky
DESIGN Elin Waite
STUDIO Ultragraphics
CLIENT Westways Magazine

DIMENSIONS 8¼ × 10⅞″ (21 × 28 cm) Editorial/103

The Metropolitan Museum of Art

Bulletin
Fall 1979

TYPOGRAPHY/DESIGN	David Barnett
TYPE SUPPLIER	York Typographers
STUDIO	David Barnett Design
CLIENT	Metropolitan Museum of Art
PRINCIPAL TYPE	Helvetica Light
DIMENSIONS	8½ × 11″ (22 × 28 cm)

Time Line of Culture in the
Nile Valley and its Relationship
to Other World Cultures

The Metropolitan

Dynastic Period

New Kingdom

Dynasty 18

Thutmosis II, the fourth king of
Dynasty 18, died at a young age,
leaving behind his queen and
sister, Hatshepsut, and his young
son, Thutmosis III. Hatshepsut
became regent for the boy but
seized full power for herself be-
fore he came of age. She con-
structed an imposing funerary
temple, shown above, in Deir el
Bahri, next to the mortuary
temple of Nebhepetra Mentu-
hotpe, the founder of the Middle
Kingdom. The architect of the
Hatshepsut temple was the chief
steward, Senmut. The building
consisted of three terraces, lined
with pillared porticoes and
connected by ramps, and was
exquisitely set off by a cliff which
formed the temple's backdrop.
When Thutmosis III finally
regained the throne, he proved to
be an able warrior and strong
ruler, conquering parts of Syria
and Palestine and subduing the
kingdom of Mitanni.

Amenhotpe III enjoyed the
riches of the Egyptian Empire at
a luxurious court. His son and
successor, Amenhotpe IV, was
interested primarily in religious
doctrine and worshipped the
god Aton, the power in the sun-
disk, to the exclusion of the
other Egyptian gods. He changed
his own royal name to Akhenaton
and built a new capital city
called "Horizon of the Aton"
in Middle Egypt. In the arts,
a tendency toward natural-
ism developed. The sculpture
above represents Akhenaton's
queen, Nafertiti, and is an out-
standing example of the art of
this period. Excavated in a
sculptor's studio in el-Amarna,
this unusual bust is thought to
be a model executed by a master
sculptor.

*Above: Funerary temple of
Hatshepsut at Deir el Bahri.
Left: Impression of a Mitannian
seal from northern Iraq;
Metropolitan Museum of Art.*

*Above: Bust of Queen Nafertiti;
Aegyptisches Museum, Berlin.
Left: Phoenician bowl from
Syria; Metropolitan Museum
of Art.*

DESIGN Rudolph de Harak
TYPE SUPPLIER CompoSet
STUDIO Rudolph de Harak & Associates, Inc.
CLIENT Metropolitan Museum of Art

PRINCIPAL TYPE Caslon
DIMENSIONS 4⅛ × 13¼″ (11 × 34 cm)

TYPOGRAPHY/DESIGN	Douglass Scott/Christopher Pullman
TYPE SUPPLIER	Zee Ann MacDonald
STUDIO	WGBH Design
CLIENT	WGBH Radio
PRINCIPAL TYPE	Body: Century Expanded Heads: Univers 75
DIMENSIONS	8½ × 11″ (22 × 28 cm)

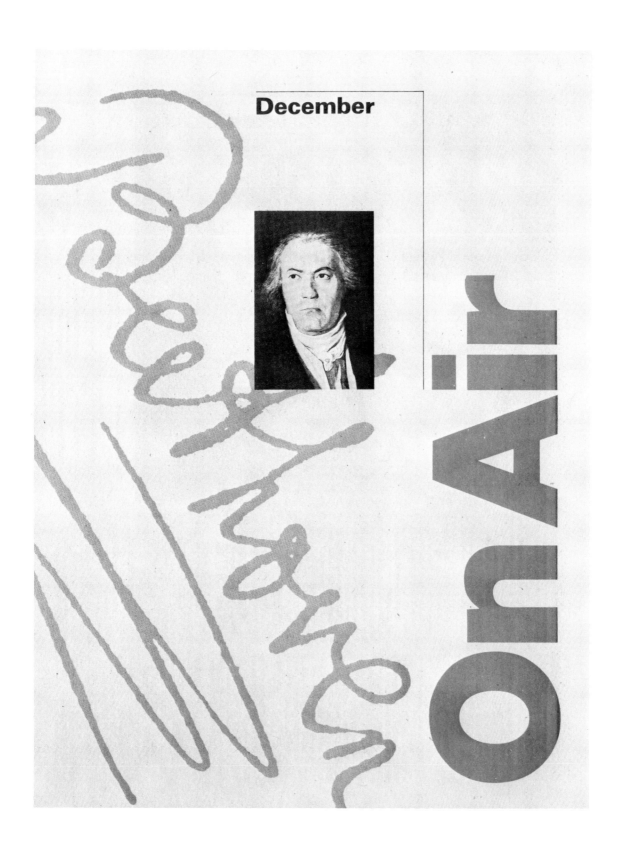

TYPOGRAPHY/DESIGN Douglass Scott/Christopher Pullman/
 Tsuneo Taniuchi
TYPE SUPPLIER Zee Ann MacDonald
STUDIO WGBH Design
CLIENT WGBH Radio

PRINCIPAL TYPE Body: Century Expanded
 Heads: Univers 75
DIMENSIONS 8½ × 11" (22 × 28 cm)

On Air

Story Litchfield for the BSO

Seiji Ozawa with Deng Xiaoping during the BSO's recent tour of China. Hear their final Peking concert Tue the 29th at 8pm.

Masterpiece Radio Theatre

Featured this month: dramatizations of works by Leo Tolstoy and Edith Wharton.

Masterpiece Radio Theatre premieres on 'GBH Radio Sat the 5th at noon.

May
WGBH Radio
89.7 fm

TYPOGRAPHY/DESIGN	Douglass Scott/Christopher Pullman
TYPE SUPPLIER	Zee Ann MacDonald
STUDIO	WGBH Design
CLIENT	WGBH Radio
PRINCIPAL TYPE	Body: Century Expanded Heads: Univers 75
DIMENSIONS	8½ × 11″ (22 × 28 cm)

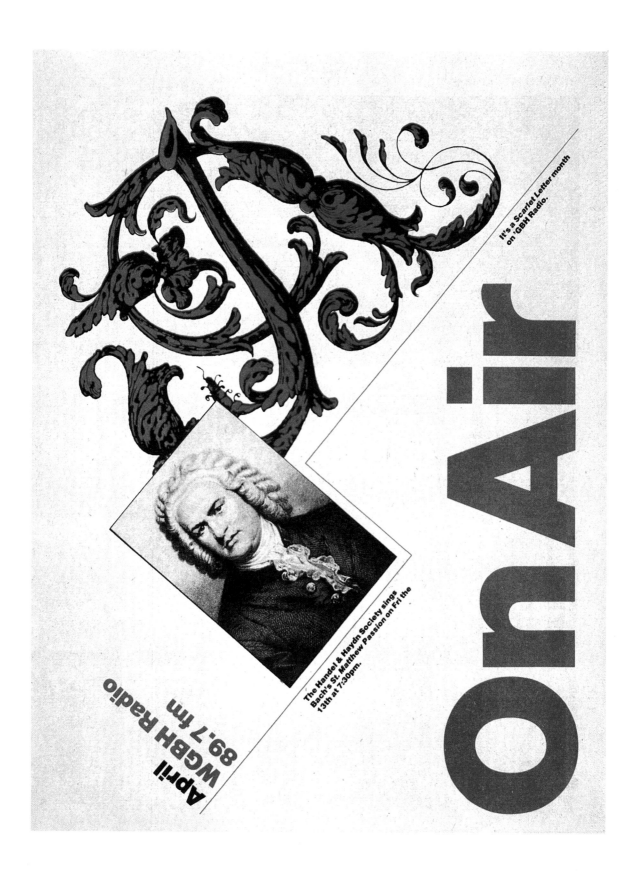

On Air

It's a Scarlet Letter month on 'GBH Radio.

The Handel & Haydn Society sings Bach's St. Matthew Passion on Fri the 13th at 7:30pm.

April
WGBH Radio
89.7 fm

TYPOGRAPHY/DESIGN Douglass Scott/Christopher Pullman
TYPE SUPPLIER Zee Ann MacDonald
STUDIO WGBH Design
CLIENT WGBH Radio

PRINCIPAL TYPE Body: Century Expanded
 Heads: Univers 75
DIMENSIONS 8½ × 11" (22 × 28 cm)

Rēalitēs

INTERNATIONAL ARTS AND CULTURES SEPTEMBER-OCTOBER, 1979 $4.00

THE MAGIC OF VENICE
BY JOSEPH WECHSBERG

PALATE AND PALETTE—
FAMOUS PAINTINGS OF FOOD

FRANCE'S LOVELY LOIRE VALLEY

CHARMING VILLA
ON A GREEK ISLAND

MAGNIFICENT PERSIAN CARPETS

IRELAND'S FABULOUS
BELLEEK PORCELAIN

JAPAN'S PEOPLE, SOCIETY,
AND PROGRESS

THE NEW STAINED GLASS

PLUS ISAAC ASIMOV ON
BACTERIAL ENGINEERING

TYPOGRAPHY/DESIGN	John Isely/Elizabeth G. Clark
TYPE SUPPLIER	David Kosten — In House
CALLIGRAPHER	Wilbur Davidson/Jake Smith
CLIENT	Realities USA
PRINCIPAL TYPE	Body: Times Roman
	Heads: Caslon 155 Black Agency Condensed
DIMENSIONS	8½ × 11″ (22 × 28 cm)

The Metropolitan Museum of Art

Bulletin
Summer 1979

TYPOGRAPHY/DESIGN David Barnett
TYPE SUPPLIER York Typographers
STUDIO David Barnett Design
CLIENT Metropolitan Museum of Art

PRINCIPAL TYPE ITC Bookman
DIMENSIONS 8½ × 11″ (22 × 28 cm)

TYPOGRAPHY/DESIGN/
CALLIGRAPHER Peter Horridge
CLIENT Arrow Books

DIMENSIONS 225 × 305 mm (8⅞ × 12″)

Henri Cartier-Bresson *Photographer*

Behind the Saint-Lazare Station, Paris, 1932

An exhibition organized by the International Center of Photography, New York.

Made possible with the generous support of the American Express Foundation.

TYPOGRAPHY/DESIGN	Christine Nardello
TYPE SUPPLIER	TGI
STUDIO	American Express Company Creative Services
CLIENT	American Express Foundation
PRINCIPAL TYPE	Body: Times Roman Heads: Pistilli Roman/Bauer Bodoni Black
DIMENSIONS	21 × 26″ (53 × 66 cm)

'LUNA': THE LAST TABOO

Using the Camera as Voyeur, Director Bernardo Bertolucci
Confronts the Incestuous Feelings He Says We All Have

BY JONATHAN COTT

PHOTOGRAPH BY MAUREEN LAMBRAY

TYPOGRAPHY/DESIGN	Christopher Austopchuk/ Mary Shanahan
TYPE SUPPLIER	Typovision +/In House Typositor
STUDIO/CLIENT	Rolling Stone Magazine
PRINCIPAL TYPE	Body: Cloister Old Style Heads: Berling
DIMENSIONS	22½ × 13½" (57 × 34 cm)

TYPOGRAPHY/DESIGN	Oswaldo Miranda (Miran)
TYPE SUPPLIER	Gravartex
STUDIO	Miran Estúdio
CLIENT	Newspaper Diário do Paraná
PRINCIPAL TYPE	Body: Times New Roman Italic Heads: Windsor
DIMENSIONS	34 × 54 cm (13⅜ × 21¼″)

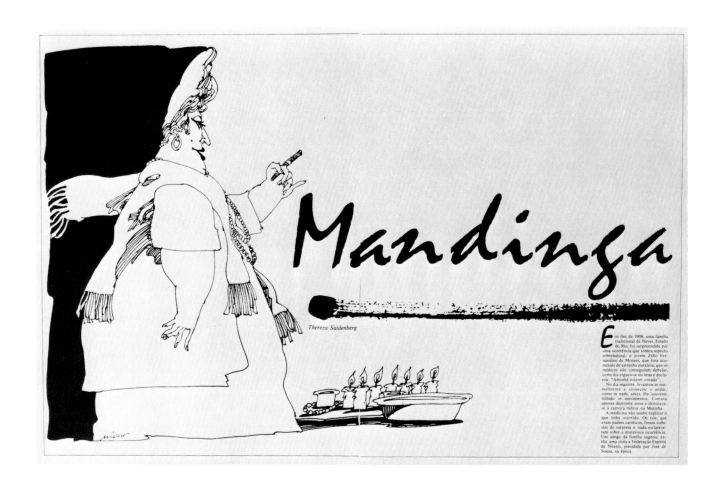

Thereza Saidenberg

Em fins de 1908, uma família tradicional de Neves, Estado do Rio, foi surpreendida por uma ocorrência que tomou aspecto sobrenatural: o jovem Zélio Fernandino de Moraes, que fora acometido de estranha paralisia, que os médicos não conseguiam debelar, certo dia ergueu-se do leito e declarou: "Amanhã estarei curado".

No dia seguinte, levantou-se normalmente e começou a andar, como se nada, antes, lhe houvesse tolhido os movimentos. Contava apenas dezesete anos e destinava-se à carreira militar na Marinha.

A medicina não soube explicar o que tinha ocorrido. Os tios, que eram padres católicos, foram colhidos de surpresa e nada esclareceram sobre a misteriosa ocorrência. Um amigo da família sugeriu, então, uma visita à Federação Espírita de Niterói, presidida por José de Souza, na época.

TYPOGRAPHY/DESIGN	Oswaldo Miranda (Miran)
TYPE SUPPLIER	Gravartex
STUDIO	Miran Estúdio
CLIENT	Newspaper Diário do Paraná
PRINCIPAL TYPE	Body: Times New Roman
	Heads: Mistral
DIMENSIONS	34 × 54 cm (13⅜ × 21¼")

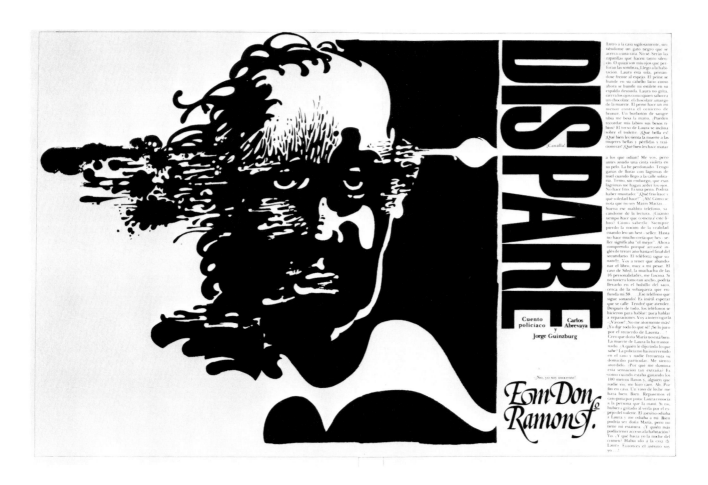

TYPOGRAPHY/DESIGN Oswaldo Miranda (Miran)
TYPE SUPPLIER Gravartex
STUDIO Miran Estúdio
CLIENT Newspaper Diário do Paraná

PRINCIPAL TYPE Body: Garamond Jornal
 Heads: Helvetica Super Versai

DIMENSIONS 34 × 54 cm (13⅜ × 21¼")

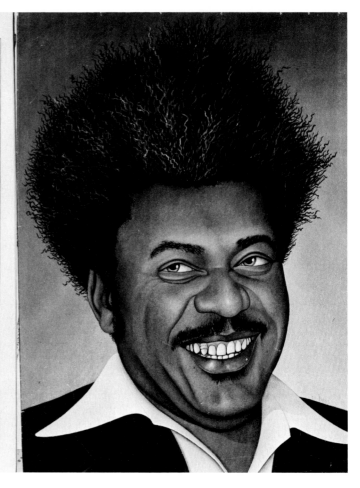

PROFILE BY STU BLACK

LORD
OF·THE·RING

*Don King's "Rumble in the Jungle" was only the prelim to his
"Hustle of the Muscle." As the ex-con-cum-boxing-promoter humbly admits,
"I don't make waves; I am the wave."*

To hear fight promoter Don King tell it, he is a major reason Jimmy Carter lives in the White House. According to King, back in 1976, President Gerald Ford met with Muhammad Ali and was about to ask the champ for a political endorsement. There was a good chance that Ali, flattered by the executive request, would give him that nod. And, Ali being Ali, it would have had a major effect on the black vote. But King, who had given substantial sums of money to Carter's campaign before the nominating convention, had access to Carter's inner circles. He got in touch with a Carter intimate, advised him of the situation and suggested that candidate Carter either call Ali or start paying closer attention to the price of peanut futures. Carter chose the former, Ali remained politically neutral, and blacks gave Carter more than 90 percent of their vote.

Don King, of course, is not a ward politician. Rather, he is the spiritual heir to Tex Rickard and Mike Jacobs, two ballsy promoters who ran worldwide boxing and helped establish New York's Madison Square Garden as the home of the sport. It was Rickard who promoted Jack Dempsey, and who put together boxing's first one-million-dollar gate. He literally ruled the boxing world during the Roaring Twenties. It was Jacobs who promoted Joe Louis, and who once had four championship bouts on one card. He was boxing's top promoter from the reign of Hitler till the

Stu Black last slugged it out in out (July 1978) with "Mike Rossman: The Fighting Jew."

advent of television. And it is Don King who has promoted George Foreman, Muhammad Ali and Larry Holmes; who was associated with the "Rumble in the Jungle"; and who has played kingmaker in the American political system.

Don King is the ubiquitous hustler on the make, and he's making it. He is a large man (6'2", 235 pounds), with a neatly trimmed mustache, a soft smile and an almost teddy-bear countenance. In his mid-40s, King looks like a former linebacker who stopped doing sit-ups five years ago. He is affable, almost humble, though his verbiage is an amalgamation of street jive and four years of fondling a dictionary in prison, and he's about as quiet as a just-vaccinated baby. He's also about as invisible as Dolly Parton at a transvestite dwarf convention. His extraordinary hair, impossible to miss, is a beacon. It stands straight up like steel wool at attention. "It is an indication I am a maverick," King says proudly. "I cannot be intimidated. The nigger is not concerned with how he looks."

King came out of nowhere to reach the pinnacle of boxing in just seven years. While better-connected people like Jack Kent Cooke and Jerry Perenchio have appeared on the pugilistic scene for a moment, then scooted off, King has stayed and has become *the* premier promoter.

Still, there are those who take issue with King's ranking as promoter. Bob Arum, King's bitter rival, for one. To Arum, King remains the rogue ex-con from Cleveland who has cut into his action. He will take any opportunity to remind one that King

served four years at Marion Correctional Institution in Ohio for manslaughter.

We are in Arum's expensive, Park Avenue law office in New York City. A cold, steady rain beats against the window. "Let me tell you something about Don King," Arum, an almost antiseptic-looking, well-dressed man, says in a low, tense voice. A frown covers his face. "Anyone who could murder another human being is capable of anything. You have to wonder about the mentality in this type of incident. He killed a guy. It sort of makes you queasy, sick to your stomach."

Arum, board chairman of Top Rank, Inc., leans forward in his chair, peers through his glasses, contemplates his next statement. On the wall behind him, pictures of Martin Luther King and Robert Kennedy hang prominently. Plaques on the other walls inform visitors that Arum was once an assistant United States Attorney under Bobby Kennedy as well as a member of Louis Nizer's prestigious law firm. Promotional posters from several Muhammad Ali fights he has staged also circle the room. A conservative demeanor backed by an impressive set of credentials.

"King is a man without principles," Arum continues, his voice a bit louder. "The FBI and the IRS were in to see me. It's no secret that King borrowed money from the Mob. To date he's only succeeded in paying off the interest. He still owes the principal. He's into them for a million and a quarter dollars, maybe a million and a half."

Serious charges, especially since they're made by an attorney, a man well versed in libel laws. Yet, before I ever met Don King, I asked top boxing and media people if they had heard of King's alleged mobster

78 PAINTING BY MARK HESS

DESIGN Michael Brock/James Kiehle
TYPE SUPPLIER Alpha Graphix Inc./
 Computer Typesetting Services Inc.
CLIENT OUI Magazine
PRINCIPAL TYPE Body: Times Roman
 Heads: Bembo
DIMENSIONS 8⅜ × 10⅞″ (21 × 28)

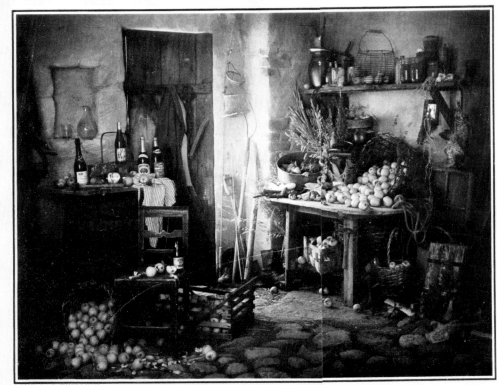

drink

By EMANUEL GREENBERG

SAUCE FROM THE APPLE

eve's favorite fruit
makes an ideal quaff for fall

TYPOGRAPHY	Theo Kouvatsos
DESIGN	Tom Staebler
TYPE SUPPLIER	Ray Miles
CALLIGRAPHER	Rotoprint
CLIENT	Playboy Magazine
PRINCIPAL TYPE	Body: Baskerville
	Heads: Poor Richard
DIMENSIONS	16½ × 11″ (42 × 28 cm)

Jim Spanfeller's Fantastic Airplane

ILLUSTRATED BY JIM SR.
WRITTEN BY JIM JR.

In a time and place not too different from the here and now there lived an artist named Jim Spanfeller.

Jim had worked for many years in a small cluttered studio in his home. The artist had many interesting things and beautiful creatures around his house. But his favorite subject to draw was a particular rose that grew in his own back yard. It seemed to symbolize the serenity and beauty that make life worthwhile.

Jim would often lace up his best pair of sneakers, take his sketchbook and pen and walk through the small wood surrounding his house. Occasionally stopping along the way, he would draw pictures of all the interesting things he saw.

But as he got older and saw many different seasons come and go through his small world, Jim gradually began to develop a strange sadness in his heart. They were feelings of dissatisfaction. It occurred to Jim that he just might be missing something.

All artists have their muses, and Jim was no exception. Muses are strange mystical beings that are born in the hearts of the people they help. But they do not appear to everyone. Some people never take the time to create their own muse, or are not fortunate enough to realize that they could have one.

Gasping as one, all the tiny creatures immediately replied that one should not question one's life. Hard work and clean living were all that was needed for a pure heart and satisfied soul.

Taken aback, Jim stood up for a minute to reflect on this new piece of advice. "No," he finally said with a determined glare, "that's not it. There must be something more."

Glumly the artist reflected on his disillusionment. The small Bird who lived in the pine trees in the back yard flew down to talk with him. The Bird had never really been very close to Jim. Every winter the winged creature would fly south, and thus she was in the pine trees for only half the year. Because of her long absences each year, the Bird was considered somewhat of an outsider by the other creatures around the house, and as such she was never really included in the conversations at the artist's windowsill. Usually she would simply sit in her tree and listen to the talks that went on below her. This had been the case tonight. The Bird had been listening and watching all that had been happening.

She was touched by the artist's sorrow, but she told him that his problem lay in the fact that he had seen so little of the world. "Take a trip someplace and look for the truth," said the Bird. But Jim wasn't sure. Where should he go? What was he to look for? The Bird answered, "There is a place I've heard of, high above the clouds, way up next to the sun where only the biggest birds can fly. I have been told that there one can see all that is needed to gain the wisdom to understand life."

Perhaps the Bird was right, thought Jim. Maybe at this special place above the clouds he could find the truth. Maybe he could see just what his problem was from such a place. The Bird continued. "With the help of your muse you might be able to build a magic airplane to take you to this place above the clouds."

Yes, **yes, yes!!** All this was right, Jim thought. He was going to draw a magic airplane and go to that place above the clouds.

Jim's confidence in his decision was interrupted by a low rasping voice. "It will never work," said the Snake, who was vain, self-centered, and something of a crank. He went on to tell the artist that people who don't accept who they are are never rewarded. One should be content with one's place in life.

Since the Snake was always negative about everything and disapproved of anything new, the artist was not discouraged by the Snake's words. Jim told his old friend that he still planned to build the airplane. This, of course, irritated the Snake no end, and the reptile crawled away in the wood muttering angrily to himself, "Wrong, wrong, wrong."

The next evening, just before it got dark, Jim went for a long walk to clear his mind before sitting down at his drawing board.

Coming upon the pond, he decided to consult with his friend the Fish. Jim told the finned creature about his problem and his proposed solution. The Fish thought that the airplane was all well and good, but said that if Jim had asked him first, he would have told him that a magic sub-

TYPOGRAPHY/DESIGN Herb Lubalin
TYPE SUPPLIER Photo-Lettering, Inc.
CALLIGRAPHER Jim Spanfeller Sr.
STUDIO Herb Lubalin Associates Inc.
CLIENT International Typeface Corporation

PRINCIPAL TYPE Clearface (ITC)
DIMENSIONS 22 × 14½" (56 × 37 cm)

In 1906, the great Edward Johnston produced the modern definitive handbook for calligraphers, tending to perpetuate the lettered characteristics of the mid-fifteenth-century manuals. Now, Hermann Zapf—overcoming such physical shortcomings in presentation—has designed what ITC believes to be an effective chancery script, showing itself through Zapf's virtuosity to be more capable of becoming a universally recognized hand than, perhaps, any other.

There is to our knowledge, no single typeface that is adaptable to all graphic applications. And so, as pointed out above, we have to accept many things on faith for sheer lack of ability to do otherwise. It is difficult, for example, to visualize Serif Gothic Black in, say, a wedding announcement, just as it is impossible to picture a Spencerian script in a brochure for heavy farm equipment.

Conversely, ITC Zapf Chancery has a multiplicity of applications. But it, too, can be badly misused in the wrong place at the wrong time for the wrong product or service. As a result, we come down to the very nature of this article. It is to demonstrate, to the best of our ability, the broad spectrum of what we feel are the proper applications for this elegant calligraphic face. And, to aid the reader in his/her further understanding of the demonstration, we have tried to use as many of the available variations as possible.

On the following eight pages, we will attempt to show suggested uses of ITC Zapf Chancery in both display and text to help solve various graphic problems. Problems such as one finds in a wedding announcement, a diploma, a legal document, a restaurant menu, a bible page, a book jacket, a greeting card, cosmetic and other packages and a corporate letterhead, etc., etc.

Of course, there are many more applications for this highly versatile typeface. Space limitation, however, has dictated certain selections. The rest is up to your very fertile imaginations.

H.L.

Everytime I write one of these introductions to an 8-page color feature, I (1) regret having done it and (2) get into trouble and complicate my life.

Preparing them on any subject I care to choose makes me sound like an authority on everything which, I assure you, I'm not. For instance, some time ago I touched on a subject far afield from my area of expertise. The consequence was that I was instantly pinpointed as an expert and one who wasn't afraid to speak my mind.

So the usual happened. A magazine reporter, a very attractive young lady, invaded my office about a month back with a tape-recording machine, flicked it on, and proceeded to deluge me with questions. Although essentially a shy and humble person, I obliged and actually managed to speak rather forcefully on the subject—rationalism versus mysticism—with myself, at those who know me know, strong on the side of rationalism.

When we were through and the magazine ms. was packing up—not willing to let well enough alone, I volunteered on impulse, "I will give you a practical example of the difference between mysticism and rationalism. A mystic would accept without question the fact that that little object has recorded our voices simply because you say it has. A rationalist, on the other hand, would say, 'Let me hear the damn thing before you leave.'"

The young lady smiled. She said, smiling patronizingly, "I have recorded hundreds and hundreds of interviews, and this machine has never failed me." I'm sure of that," I said, smiling back, "but just to humor me and my rationalism, let's play it back and make sure."

So, still patronizingly, she played it back. And lo and behold, no voices had been recorded. Nothing. The smile vanished. "I don't understand it," she said. "I know," I said, "this is the first time such a thing has happened to you."

This occurrence got me to thinking how mystical even rationalists are. It is impossible to check everything personally; it is impossible to make sure that everything is personally understood by our own personal brain. We have to accept many things on faith for sheer lack of ability to do otherwise.

In any case, here I am again taking the plunge and will no doubt live to regret it.

This time out, ITC thought that—instead of just being a show-off piece—it would be appropriate to use our 8-page color section as a service piece; in effect, a guide to the various images of ITC Zapf Chancery and a handy illustrated manual as to the many applications for the unusual array of alternate characters, ligatures, start letters, final letters, and flags.

When calligraphy reached its height in the Renaissance, a writing hand known as cancellaresca (or chancery script) emerged. It grew out of the two-Caroline hand, and was written with greater speed. Although there was a slant to it, slanting was not obligatory, so the cursive quality was built into the letters. The forms were more compressed than those of scrittura humanistica. The rhythmic beat of nearly-even strokes and space (as in black letter) created a definite pattern, and round forms became elliptical, approaching parallelograms.

About the middle of the sixteenth century, several writing manuals appeared demonstrating the forms and flow of chancery scripts. Arrighi, Tagliente, and Palatino were the most widely known writers of these manuals. Their books, while certainly quite beautiful, yet tend to give readers a false impression of the rhythm of chancery cursive. The examples are cut in wood—and with great technical mastery—but they somehow lack the spirit of the writing, causing Arrighi to point out what was certainly true then: "The press can never entirely represent the living hand."

(OR, HOW
TO GET THE
MOST OUT OF
ITC ZAPF
CHANCERY.)

TYPOGRAPHY/DESIGN Herb Lubalin
TYPE SUPPLIER Photo-Lettering, Inc.
STUDIO Herb Lubalin Associates Inc.
CLIENT International Typeface Corporation

PRINCIPAL TYPE Zapf Chancery
DIMENSIONS 22 × 14½" (56 × 37 cm) Editorial/121

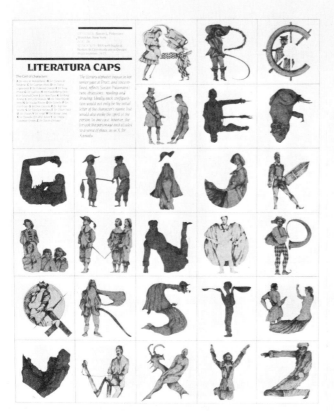

LITERATURA CAPS

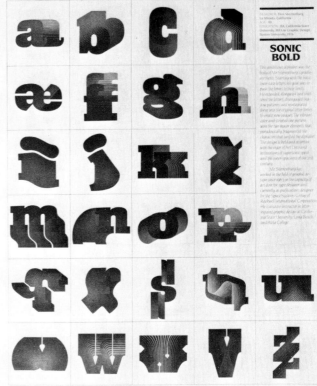

SONIC BOLD

TYPOGRAPHY/DESIGN	Herb Lubalin
TYPE SUPPLIER	Photo-Lettering, Inc.
CLIENT	International Typeface Corporation
PRINCIPAL TYPE	Novarese
DIMENSIONS	22 × 14½" (56 × 37 cm)

There is a characteristic Italian style, especially in motor yachts, that Europe's boat-watchers recognize in ports from Piraeus to Stockholm. "Is she Italian?" they will wonder. "No, perhaps Dutch." "But look at the line of the superstructure; she's Italian." And if they go below decks to discover joinerwork so perfect that it might have grown that way, and furnishings as considered and sophisticated as those of a modern Mediterranean villa, then they know she's Italian. □ It is a unique style which seems to have borrowed its rakish, angular lines from military vessels rather than from the working boats that have influenced the style of American and Northern European motor yachts. And it is a style which, like that of European automobiles, is essentially aerodynamic, a clean sweep of line reminiscent of aircraft.

THE ITALIAN
STYLE BY MARIO TEDESCHI

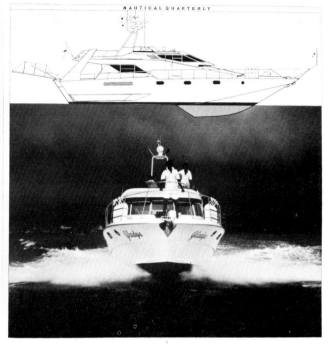

TYPOGRAPHY/DESIGN	B. Martin Pedersen
STUDIO	Jonson/Pedersen/Hinrichs & Shakery Inc.
CLIENT	Nautical Quarterly Inc.
PRINCIPAL TYPE	Body: Goudy Old Style
	Heads: Aachen Bold
DIMENSIONS	20½ × 10¼″ (52 × 26 cm)

Editorial/123

MOVING INTO THE NON-OIL AGE

TYPOGRAPHY/DESIGN Bob Watson
TYPE SUPPLIER Type Foundry
AGENCY Needham Harper & Steers, Washington
CLIENT Mitre Corporation

PRINCIPAL TYPE Goudy Old Style
DIMENSIONS 11½ × 8½″ (29 × 22 cm)

**Human Resources Planning
and Development Guide**

TYPOGRAPHY/DESIGN	Russel Tatro
TYPE SUPPLIER	Production Typographers, Inc.
STUDIO	Pepsi-Cola Graphics Arts Dept.
CLIENT	Pepsi-Cola Co.
PRINCIPAL TYPE	Helvetica
DIMENSIONS	11 × 20″ (28 × 51 cm)

Thoughts for a winter's night from The Sand County Almanac *by Aldo Leopold, with warmest greetings of friendship and love for a splendid new year and decade.*

Our ability to perceive quality in nature begins, as in art, with the pretty. It expands through successive stages of the beautiful to values as yet uncaptured by language. The quality of cranes lies, I think, in this higher gamut, as yet beyond the reach of words.

Why is the shovel regarded as a symbol of drudgery? Perhaps because most shovels are dull. Certainly all drudges have dull shovels, but I am uncertain which of these two facts is cause and which effect. I only know that a good file, vigorously wielded, makes my shovel sing as it slices the mellow loam. I am told there is music in the sharp plane, the sharp chisel, and the sharp scalpel, but I hear it best in my shovel; it hums in my wrists as I plant a pine. I suspect that the fellow who tried so hard to strike one clear note upon the harp of time chose too difficult an instrument.

It is well that the planting season comes only in spring, for moderation is best in all things, even shovels. During the other months you may watch the process of becoming a pine.

A cardinal, whistling spring to a thaw but later finding himself mistaken, can retrieve his error by resuming his winter silence. A chipmunk, emerging for a sunbath but finding a blizzard, has only to go back to bed. But a migrating goose, staking two hundred miles of black night on the chance of finding a hole in the lake, has no easy chance for retreat. His arrival carries the conviction of a prophet who has burned his bridges.

These things I ponder as the kettle sings, and the good oak burns to red coals on white ashes. Those ashes, come spring, I will return to the orchard at the foot of the sandhill. They will come back to me again, perhaps as red apples, or perhaps as a spirit of enterprise in some fat October squirrel, who, for reasons unknown to himself, is bent on planting acorns.

The calligraphy of our names was done 30 years ago by Ray DaBoll. The pen drawing is the work of the great Montana artist, C. M. Russell (1864–1926). The type for this printed greeting was set by hand and printed at the Acorn Press. The type will be distributed.

The act of distributing type is a ritual of returning individual pieces of type to their proper place. It is not intellectually stimulating but a sense of satisfaction and serenity results. There is a promise of ready usefulness. It is a time for gathering strength and of renewed purpose.

TYPOGRAPHY/DESIGN	John Michael
TYPE SUPPLIER	Acorn Press
CALLIGRAPHER	Ray DaBoll
STUDIO	Acorn Press
CLIENT	Jean & John Michael
PRINCIPAL TYPE	Body: Trajanus/Caslon Old Face/ Original Old Style Italic/Optima
DIMENSIONS	7 × 25″ (18 × 64 cm)

TYPOGRAPHY/DESIGN Bennett Robinson
TYPE SUPPLIER Tri-Arts Press, Inc./S.D. Scott
STUDIO Corporate Graphics, Inc.
CLIENT Champion Papers, Division of
 Champion International Corp.

PRINCIPAL TYPE Baskerville
DIMENSIONS 8½ × 11" (22 × 28 cm) Editorial/127

Julia Child & More Company

by Julia Child

More of the wonderful dishes she cooks for company. More gala feasts of every kind — from an old-fashioned chicken dinner to an elegant lobster lunch to a lavish menu (you can do it solo) for a crowd. Her detailed recipes for everything she demonstrates on her *second* cooking-for-company television series. And more!

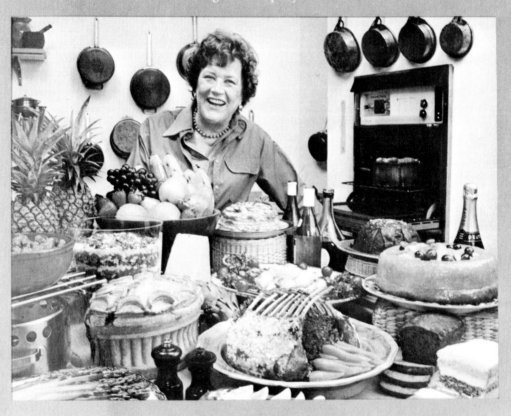

TYPOGRAPHY/DESIGN	Christopher Pullman/Stuart Darsch/ Lorraine Ferguson
TYPE SUPPLIER	Monotype Composition Co., Baltimore
STUDIO	WGBH Design
CLIENT	Alfred A. Knopf
PRINCIPAL TYPE	Body: Sabon Heads: Sabon Bold
DIMENSIONS	17 × 10⅞" (43 × 28 cm)

MAYORS
MADAMS
&
MADMEN

By Norman Mark

TYPOGRAPHY/DESIGN/
CALLIGRAPHER Joseph M. Essex
TYPE SUPPLIER Photofont
AGENCY Burson · Marsteller/Design Group
CLIENT Chicago Review Press

PRINCIPAL TYPE Body: ITC Garamond Condensed
 Heads: Benguiat Condensed
DIMENSIONS 6½ × 9¼″ (17 × 24 cm)

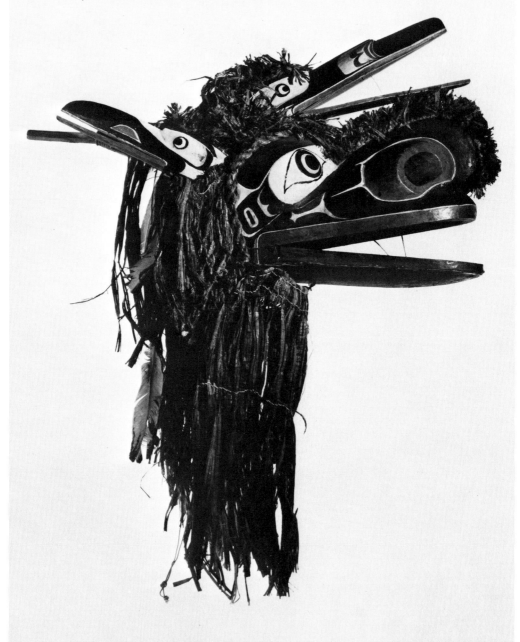

KWAKIUTL ART

UNIVERSITY OF WASHINGTON PRESS *Seattle & London*

TYPOGRAPHY/DESIGN	Audrey Meyer
TYPE SUPPLIER	University of Washington, Dept. of Printing
CLIENT	University of Washington Press
PRINCIPAL TYPE	Garamond
DIMENSIONS	17 × 26″ (43 × 66 cm)

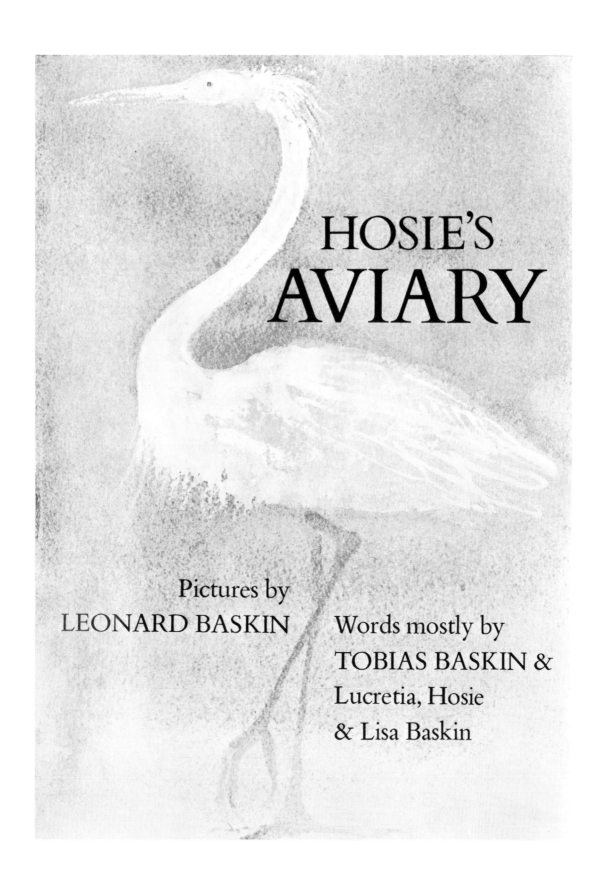

HOSIE'S
AVIARY

Pictures by
LEONARD BASKIN

Words mostly by
TOBIAS BASKIN &
Lucretia, Hosie
& Lisa Baskin

TYPOGRAPHY/DESIGN Barbara G. Hennessy
TYPE SUPPLIER A. Colish, Inc.
CLIENT The Viking Press

PRINCIPAL TYPE Aldine Bembo
DIMENSIONS 7¾ × 11¼″ (20 × 29 cm)

LETTERS

A NOVEL

JOHN BARTH

TYPOGRAPHY/DESIGN	David Gatti/Lynn Hollyn
CALLIGRAPHER	David Gatti
AGENCY	Lynn Hollyn Associates
CLIENT	The Putnam Publishing Group
DIMENSIONS	6⅛ × 9¼″ (16 × 24 cm)

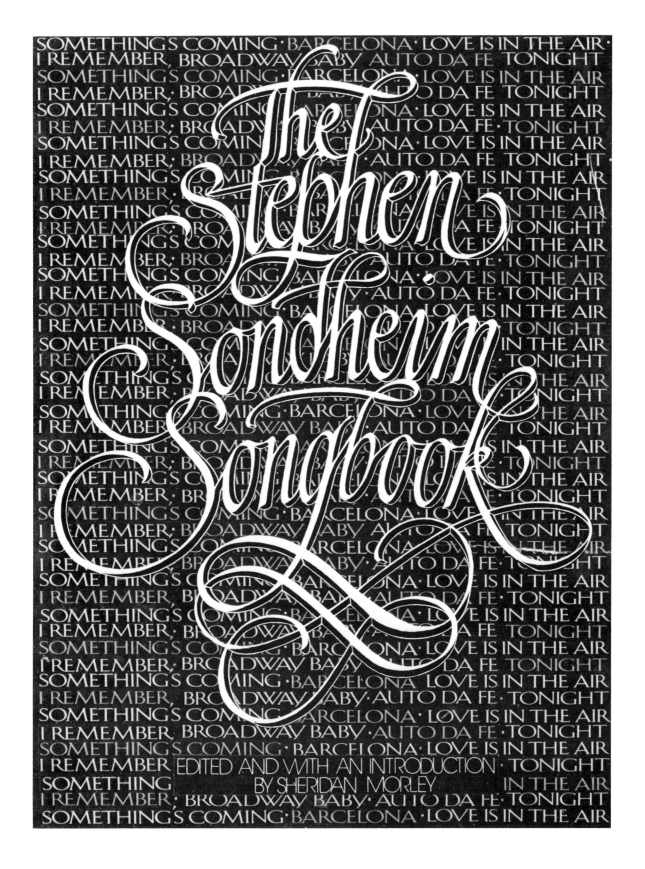

The Stephen Sondheim Songbook

EDITED AND WITH AN INTRODUCTION
BY SHERIDAN MORLEY

TYPOGRAPHY/DESIGN Gun Larson/Lynn Hollyn
TYPE SUPPLIER Marvin Kommel Productions
CALLIGRAPHER Gun Larson
AGENCY Lynn Hollyn Associates
CLIENT The Putnam Publishing Group

DIMENSIONS 8⅝ × 11⅛" (22 × 28 cm)

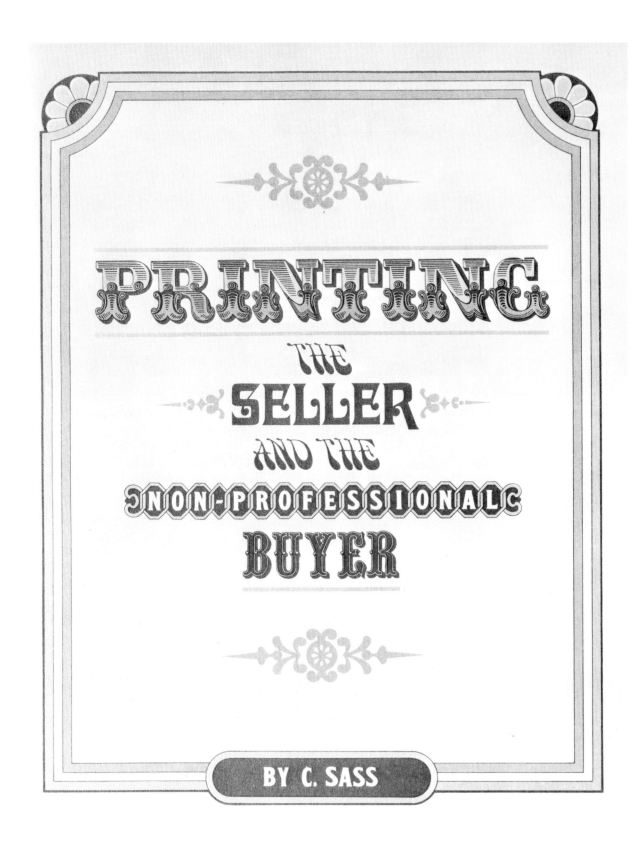

PRINTING THE SELLER AND THE NON-PROFESSIONAL BUYER

BY C. SASS

TYPOGRAPHY/DESIGN Lowell Hess
TYPE SUPPLIER/
STUDIO Lowell Hess
CLIENT Herlin Press, Inc.

PRINCIPAL TYPE Caledonia
DIMENSIONS 17 × 11" (43 × 28 cm)

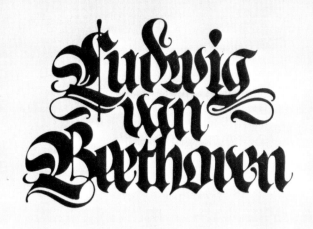

TYPOGRAPHY/DESIGN Keith Murgatroyd
CALLIGRAPHER Tony Forster
STUDIO Royle-Murgatroyd Design Associates Ltd.
CLIENT Royal Northern College of Music

PRINCIPAL TYPE Univers
DIMENSIONS 210 × 297 mm (8¼ × 11¾")

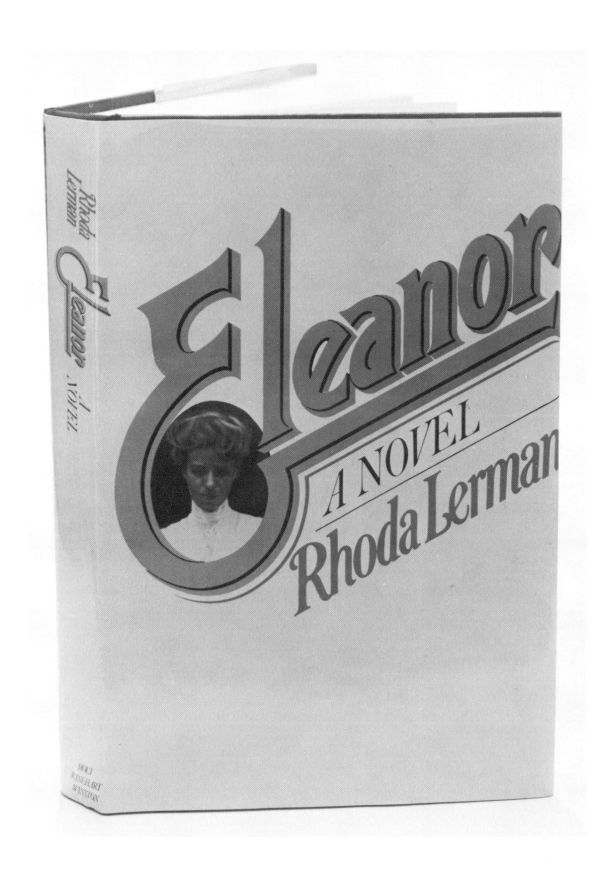

TYPOGRAPHY/DESIGN Robert Reed
CALLIGRAPHER/STUDIO Paul Bacon
CLIENT Holt, Rinehart and Winston
DIMENSIONS 6⅛ × 9¼″ (16 × 24 cm)

TYPOGRAPHY/DESIGN/
CALLIGRAPHER Olaf Leu/Fritz Hofrichter
TYPE SUPPLIER Oehms-Druck KG
STUDIO Olaf Leu Design & Partner
CLIENT Dr. Rudolf Kissel and Henninger-Braeu

PRINCIPAL TYPE Optima

THE CIBA COLLECTION OF MEDICAL ILLUSTRATIONS

VOLUME 7

RESPIRATORY SYSTEM

FRANK H. NETTER, M.D.

TYPOGRAPHY/DESIGN Pierre Lair
TYPE SUPPLIER The Type Group, Inc.
STUDIO Ciba-Geigy Medical Education Division
CLIENT Ciba-Geigy

PRINCIPAL TYPE Body: Garamond
 Heads: Garamond Bold

DIMENSIONS 9¼ × 12³/₁₆ ″ (24 × 31 cm)

TYPOGRAPHY/DESIGN Daniel Haberman
TYPE SUPPLIER Royal Composing Room, Inc.
CLIENT Finch, Pruyn & Company, Inc.,
A. Horowitz & Son, RAE Publishing Co.,
Royal Composing Room, Inc.

PRINCIPAL TYPE Body: Simoncini Garamond
Heads: Garamond
DIMENSIONS 8 × 8¼″ (20 × 21 cm)

TYPOGRAPHY/DESIGN Colin Joh/Jack G. Tauss
TYPE SUPPLIER Haddon Craftsmen (Com Com)
AGENCY The Sloves Organization
CLIENT The Franklin Library

PRINCIPAL TYPE Body: Bodoni Book
Heads: Peignot Light

 DIMENSIONS 5½ × 8³/₁₆ ″ (14 × 21 cm)

TYPOGRAPHY/DESIGN	Janet Kearns/Jack G. Tauss
TYPE SUPPLIER	Progressive Typographers
AGENCY	The Sloves Organization
CLIENT	The Franklin Library
PRINCIPAL TYPE	Body: Garamond
	Heads: Bernhard Modern Bold
DIMENSIONS	6¹/₁₆ × 8¾″ (15 × 22 cm)

TYPOGRAPHY/DESIGN Michael Mendelsohn/Jack G. Tauss
TYPE SUPPLIER Waldman Graphics Inc.
AGENCY The Sloves Organization
CLIENT The Franklin Library

PRINCIPAL TYPE Body: Electra
 Heads: Futura Display

DIMENSIONS 6 × 9¹/₁₆ ″ (15 × 23 cm)

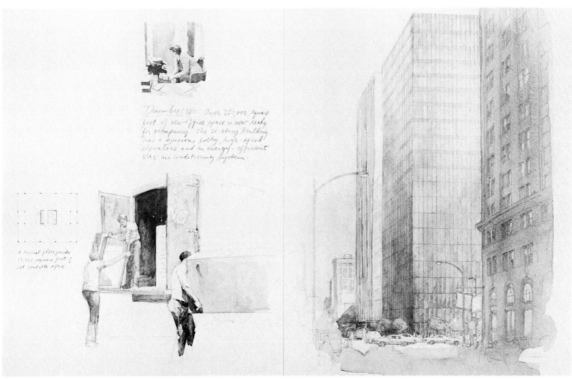

TYPOGRAPHY/DESIGN	Charles Hively
TYPE SUPPLIER	Professional Typographers
CALLIGRAPHER	Daniel Schwartz
AGENCY	Metzdorf Advertising Agency Inc.
CLIENT	Ragsdale Development Inc.
PRINCIPAL TYPE	Body: Trump Italic Heads: Trump Bold
DIMENSIONS	11⁵/₁₆ × 14¼″ (29 × 36 cm)

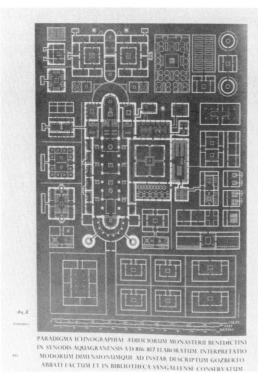

TYPOGRAPHY/DESIGN/
CALLIGRAPHER Ernest Born
TYPE SUPPLIER William Clowes, Ltd., London
CLIENT The University of California Press

PRINCIPAL TYPE Body: Monotype 80
 Heads: Perpetua Titling

DIMENSIONS 11 × 14" (28 × 36 cm)

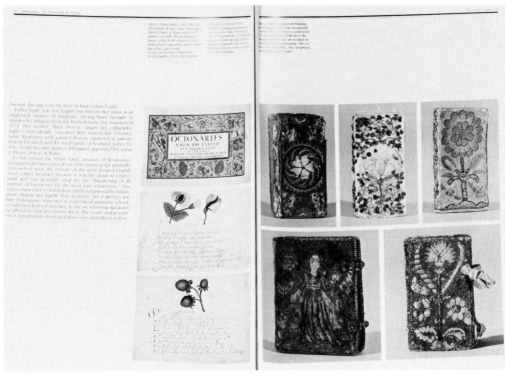

TYPOGRAPHY/DESIGN David Barnett/Stuart Silver
TYPE SUPPLIER Cardinal Type Service Inc.
STUDIO David Barnett Design
CLIENT Folger Shakespeare Library/
 Oxford University Press

PRINCIPAL TYPE Body: ITC Garamond Light
 Heads: ITC Garamond Light Italic
DIMENSIONS 9 × 12" (23 × 30 cm)

JEAN-JACQUES ROUSSEAU
BOTANY
A STUDY OF PURE CURIOSITY

Illustrated by P. J. Redouté

THE
SECOND
LETTER

18 October 1771

Since you comprehend so well, dear cousin, the basic features of plants, even though so faintly defined, that your sharp eye is already able to distinguish a family likeness within the Lily family, and since our dear young botanist takes pleasure in corollas and petals, I am about to suggest another family on which she will henceforth be able to exercise her slender knowledge. I admit the task will be somewhat more difficult, for the flowers are smaller and the foliage more varied, but it will afford both her and yourself equal enjoyment, at least if you have as much delight in following this flowery path as I have in tracing it out for you.

When in gardens the first sunbeams of spring cast their light on the Hyacinths, Tulips, Daffodils, Jonquils and Lilies-of-the-Valley, whose characteristics are already familiar to you, and illuminate your progress, other flowers such as the Wallflowers or Stocks, and Dame's Violet will soon catch your eye and demand closer examin-ation. Should you find double flowers, waste no time in examining them; they are deformed, or, if you prefer, we have embellished them according to our whim: nature is no longer there; she refuses to be reproduced by such deformed monsters; for while the most arresting part, the corolla, is reduplicated, it is at the expense of the more essential organs, which disappear beneath this splendour.

Take, therefore, an ordinary Wallflower, and proceed to examine its flower. First you will perceive an outer part, the calyx, which is

CROCUS (SAFFRON) *Crocus sativa* (see page 32)

TYPOGRAPHY Felix Gluck
DESIGN Shelagh McGee
TYPE SUPPLIER Pierson LeVesley, Oxshott
STUDIO Felix Gluck Press Ltd.
CLIENT Paddington Press Ltd., New York

PRINCIPAL TYPE Caslon 540
DIMENSIONS 7¾ × 10″ (20 × 25 cm)

TYPOGRAPHY/DESIGN Robert Fillie
TYPE SUPPLIER Lexigraphics, Inc.
STUDIO Craig Graphics, Ltd.
CLIENT Watson-Guptill Publications

PRINCIPAL TYPE Body: Baskerville
 Heads: Firmin Didot
DIMENSIONS 9 × 12″ (23 × 30 cm)

Informational

Annual Reports
Personal Graphics
Posters
Announcements
Programs
Menus

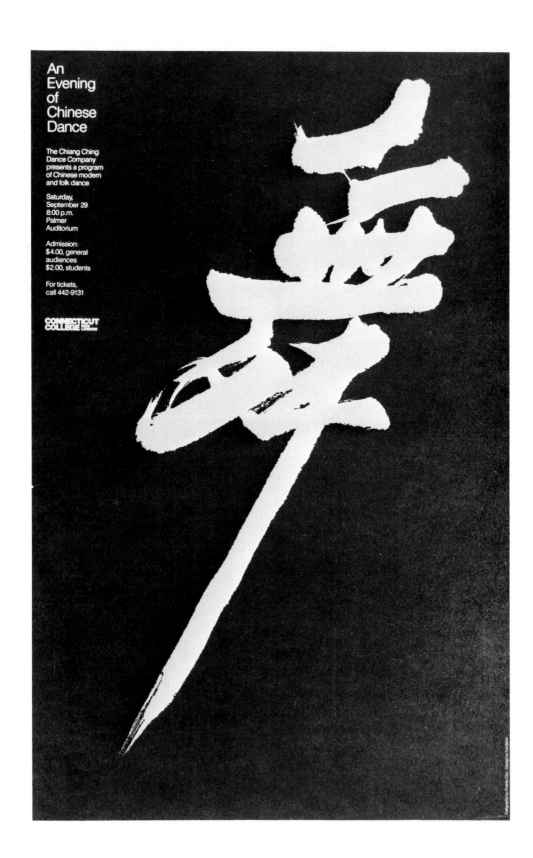

An
Evening
of Chinese
Dance

The Chiang Ching
Dance Company
presents a program
of Chinese modern
and folk dance

Saturday,
September 29
8:00 p.m.
Palmer
Auditorium

Admission:
$4.00, general
audiences
$2.00, students

For tickets,
call 442-9131

CONNECTICUT
COLLEGE New London

TYPOGRAPHY/DESIGN	Ted Bertz
TYPE SUPPLIER	Eastern Typesetting Co.
CALLIGRAPHER	Charles Chu
STUDIO	Ted Bertz/Design Inc.
CLIENT	Connecticut College, New London
PRINCIPAL TYPE	Helvetica
DIMENSIONS	14 × 22″ (36 × 56 cm)

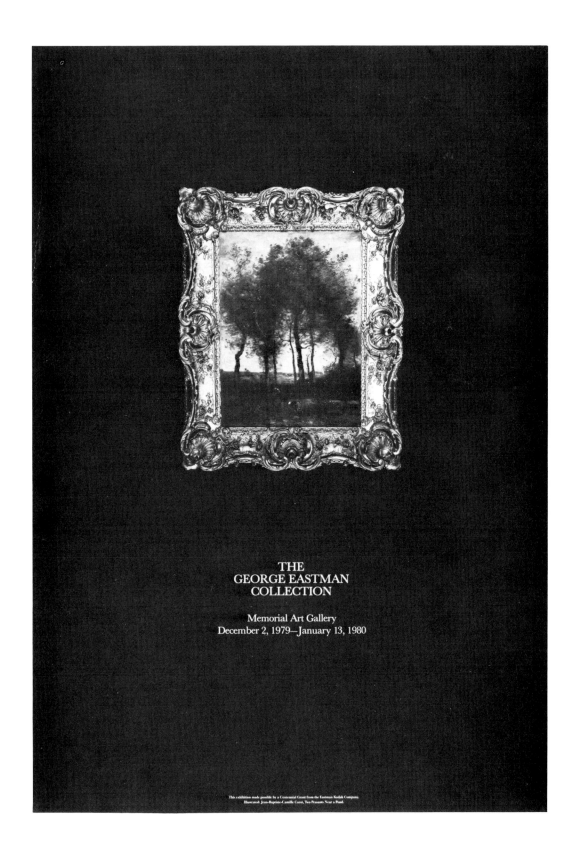

**THE
GEORGE EASTMAN
COLLECTION**

Memorial Art Gallery
December 2, 1979—January 13, 1980

This exhibition made possible by a Centennial Grant from the Eastman Kodak Company.
Illustrated: Jean-Baptiste-Camille Corot, Two Peasants Near a Pond.

TYPOGRAPHY/DESIGN	Robert Meyer
TYPE SUPPLIER	Rochester Mono/Headliners
STUDIO	Robert Meyer Design
CLIENT	Eastman Kodak Company
PRINCIPAL TYPE	Baskerville
DIMENSIONS	22½ × 32″ (57 × 81 cm)

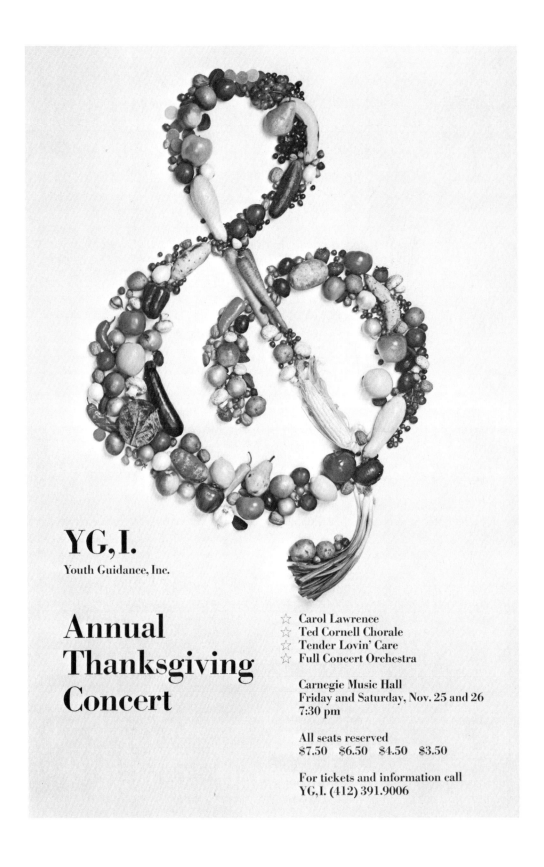

YG,I.
Youth Guidance, Inc.

Annual
Thanksgiving
Concert

☆ Carol Lawrence
☆ Ted Cornell Chorale
☆ Tender Lovin' Care
☆ Full Concert Orchestra

Carnegie Music Hall
Friday and Saturday, Nov. 25 and 26
7:30 pm

All seats reserved
$7.50 $6.50 $4.50 $3.50

For tickets and information call
YG,I. (412) 391.9006

TYPOGRAPHY/DESIGN	Eddie Byrd
TYPE SUPPLIER	Davis & Warde, Inc.
STUDIO	Byrd Graphic Design, Inc.
CLIENT	Youth Guidance, Inc.
PRINCIPAL TYPE	Bodoni Bold
DIMENSIONS	22¾ × 35″ (58 × 89 cm)

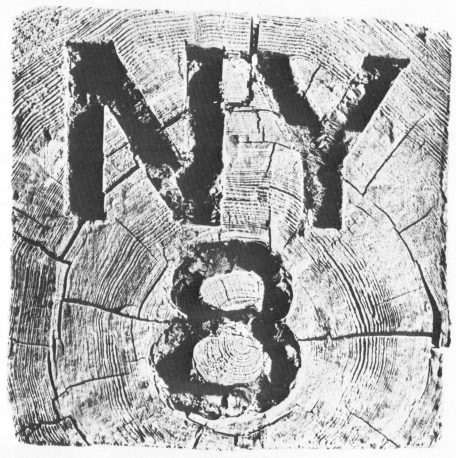

NY/8

Brad A. Edell
G. Gerry Griffin
Brower Hatcher
Pedro Lujan
Mike Metz
Robert Stackhouse
Norman Tuck
Ursula von Rydingsvard

November 18, 1979—January 13, 1980
Hours: 12-5 p.m., Tuesday-Sunday

Joe & Emily Lowe Art Gallery, Sims Hall, School of Art, College of Visual & Performing Arts, Syracuse University
This exhibition is made possible with public funds from the New York State Council on the Arts. This poster is made possible with a grant from the Institute of Museum Services, HEW.
Poster Design: Donald Arday. Photograph: Roy C. Scott

TYPOGRAPHY/DESIGN	Donald Arday
TYPE SUPPLIER	Dept. of Visual Communication, Syracuse University
CLIENT	Joe & Emily Lowe Art Gallery, Syracuse University
PRINCIPAL TYPE	Friz Quadrata
DIMENSIONS	17 × 22" (43 × 56 cm)

Informational/153

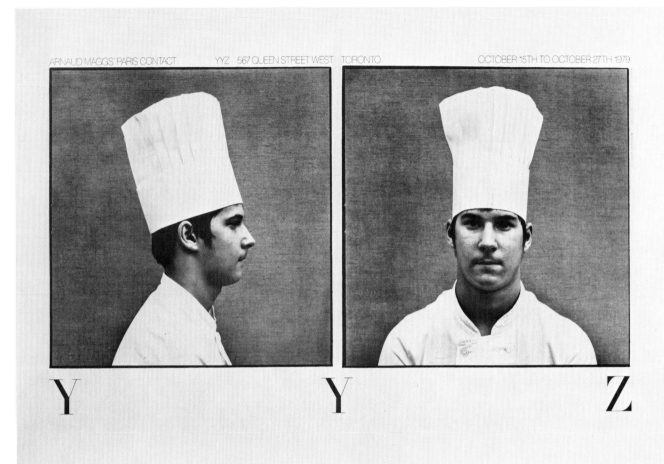

Y Y Z

TYPOGRAPHY/DESIGN Arnaud Maggs
TYPE SUPPLIER Cooper & Beatty Limited, Toronto
CLIENT YYZ Artist's Outlet/Arnaud Maggs

PRINCIPAL TYPE Body: Helvetica
 Heads: Firmin Didot

154/Informational DIMENSIONS 36 × 24" (91 × 61 cm)

SPACE GALLERY
LOS ANGELES
MAY 13-JUNE 21,1980

LUNDIN

TYPOGRAPHY/DESIGN	Rick Eiber
TYPE SUPPLIER	The Type Gallery, Inc.
STUDIO	Rick Eiber Design
CLIENT	Norman Lundin/Space Gallery
PRINCIPAL TYPE	Body: Times Roman
	Heads: Neo-Times Roman
DIMENSIONS	24 × 21½″ (61 × 54.6 cm)

Informational/155

one college, two cities

The Big Apple & The Big Orange

Parsons School of Design
New York
Otis Art Institute of
Parsons School of Design
Los Angeles

at Parsons/Otis, a year of student exchange with N.Y. or L.A. is a built-in option

For further information or catalog contact Parsons School of Design, 66 Fifth Ave., New York, NY 10011, 212-741-8910 or the Otis Art Institute of Parsons School of Design, 2401 Wilshire Blvd., Los Angeles, CA 90057, 213-388-3128

TYPOGRAPHY/DESIGN	Cipe Pineles Burtin
TYPE SUPPLIER	In House
STUDIO/CLIENT	Parsons School of Design
PRINCIPAL TYPE	Helvetica

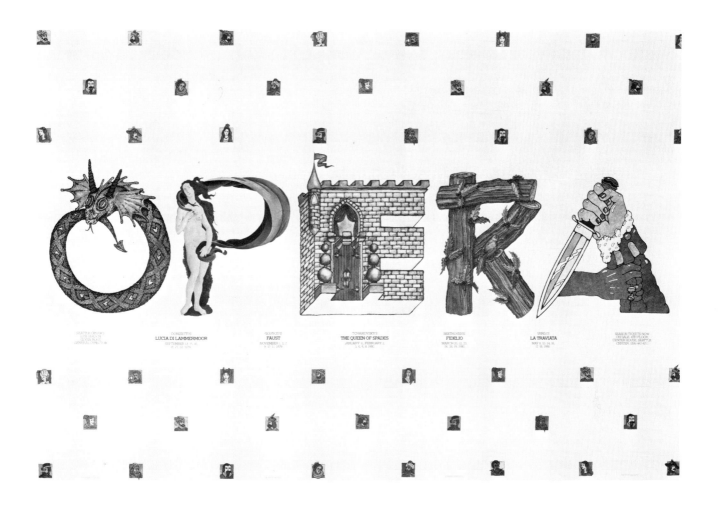

TYPOGRAPHY/DESIGN	Warren Wilkins/Tommer Peterson
TYPE SUPPLIER	The Type Gallery, Inc.
STUDIO	Wilkins & Peterson Graphic Design
CLIENT	Seattle Opera Association
PRINCIPAL TYPE	Stymie Tru-Cut
DIMENSIONS	24 × 36″ (61 × 91 cm)

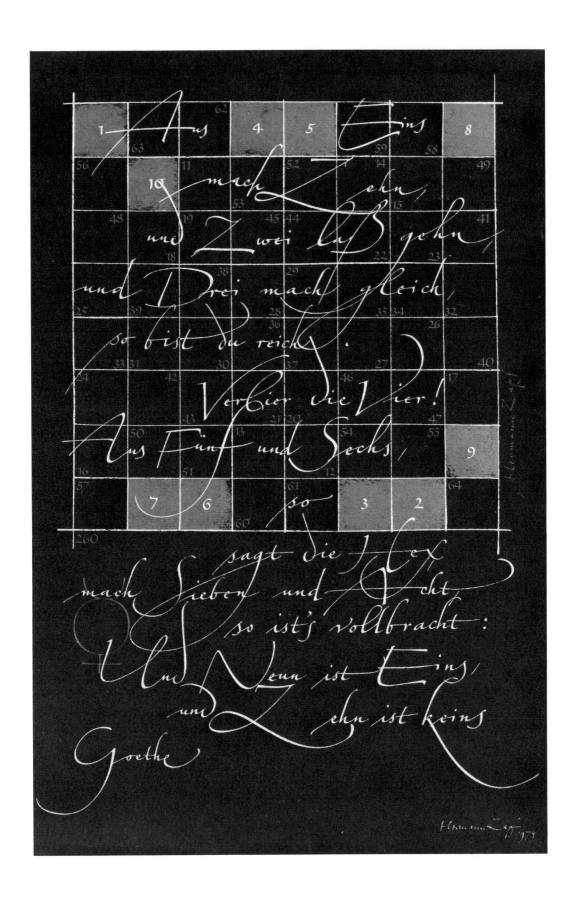

DESIGN/CALLIGRAPHER Hermann Zapf
CLIENT Letraset Deutschland GmbH
DIMENSIONS 19½ × 29¼″ (50 × 74 cm)

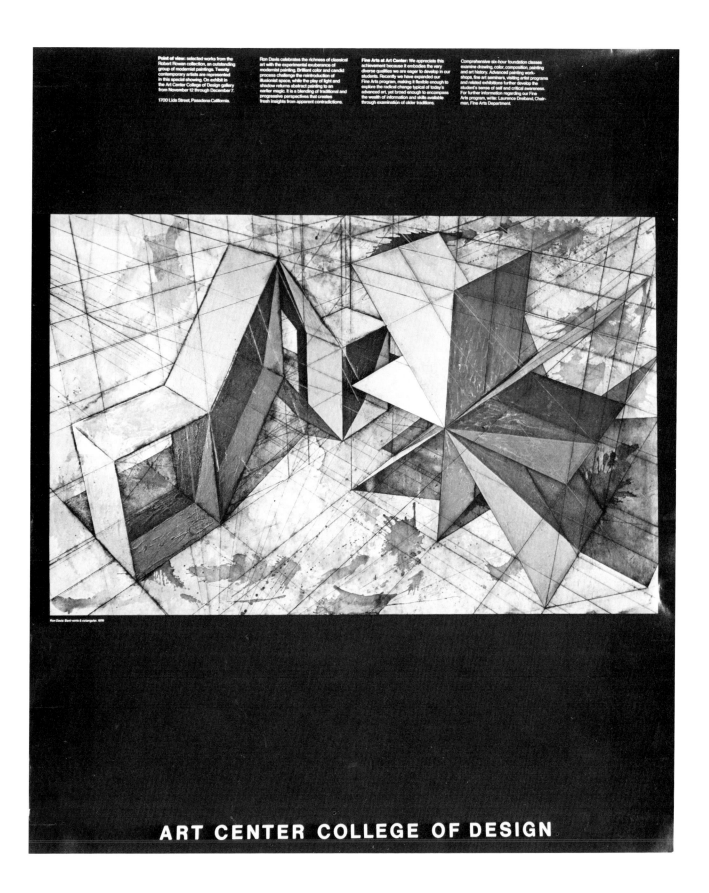

ART CENTER COLLEGE OF DESIGN

TYPOGRAPHY/DESIGN Rik Besser/Don Kubly
TYPE SUPPLIER Vern Simpson Typographers/Photype
STUDIO/CLIENT Art Center College of Design

PRINCIPAL TYPE Helvetica
DIMENSIONS 33½ × 40″ (85 × 102 cm) Informational/159

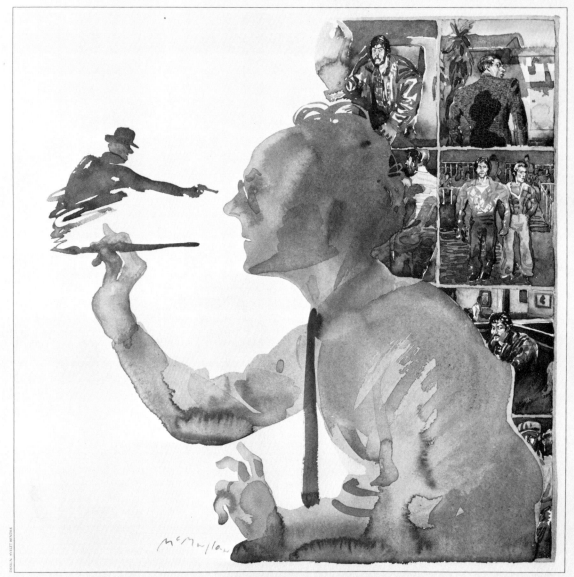

JAMES McMULLAN RETROSPECTIVE · NOVEMBER 29TH–DECEMBER 19TH

YOU ARE CORDIALLY INVITED TO THE OPENING ON THURSDAY, NOVEMBER 29TH, FROM 5:30-7:30 P.M. THE VISUAL ARTS MUSEUM, 209 EAST
23RD STREET, NEW YORK CITY 10010. MONDAY THROUGH THURSDAY, NOON TO 9:00 P.M, FRIDAY, 11:00 AM TO 4:30 P.M. CLOSED WEEKENDS.

TYPOGRAPHY/DESIGN	Ayelet Bender/Richard Wilde
TYPE SUPPLIER	Cardinal Type Service, Inc.
CALLIGRAPHER	James McMullan
STUDIO	School of Visual Arts
CLIENT	Visual Arts Museum
PRINCIPAL TYPE	Garamond
DIMENSIONS	17½ × 21⅛" (45 × 54 cm)

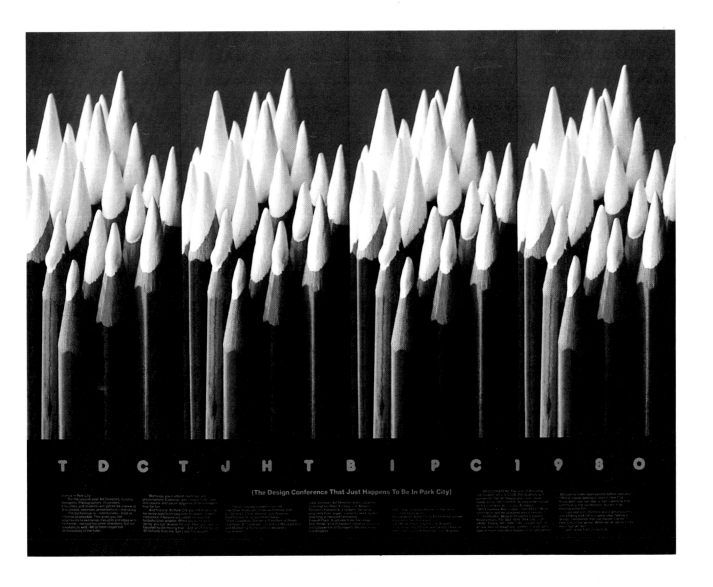

TYPOGRAPHY/DESIGN Don Weller
TYPE SUPPLIER Alphagraphix, Inc.
STUDIO The Weller Institute for the
Cure of Design
CLIENT The Design Conference That Just
Happens To Be In Park City. 1980

PRINCIPAL TYPE Body: Helvetica
Heads: Frankfurter
DIMENSIONS 24 × 20″ (61 × 51 cm) Informational/161

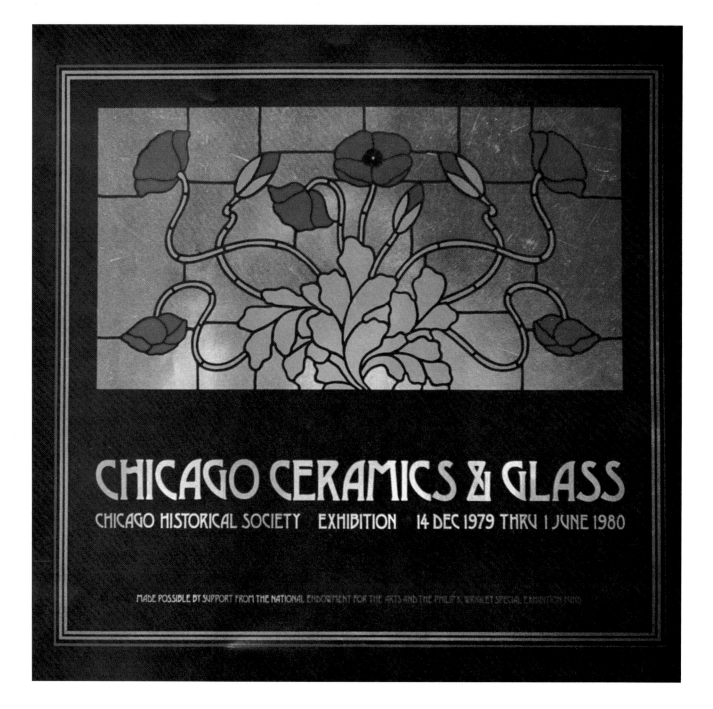

CHICAGO CERAMICS & GLASS

CHICAGO HISTORICAL SOCIETY EXHIBITION 14 DEC 1979 THRU 1 JUNE 1980

MADE POSSIBLE BY SUPPORT FROM THE NATIONAL ENDOWMENT FOR THE ARTS AND THE PHILIP K. WRIGLEY SPECIAL EXHIBITION FUND

TYPOGRAPHY/DESIGN	Barbara Fahs Charles/ Robert Staples
TYPE SUPPLIER	Adcomp Inc.
STUDIO	Staples & Charles Ltd.
CLIENT	Chicago Historical Society
PRINCIPAL TYPE	Heads: S & C Bastard Desdemona
DIMENSIONS	25 × 25" (64 × 64 cm)

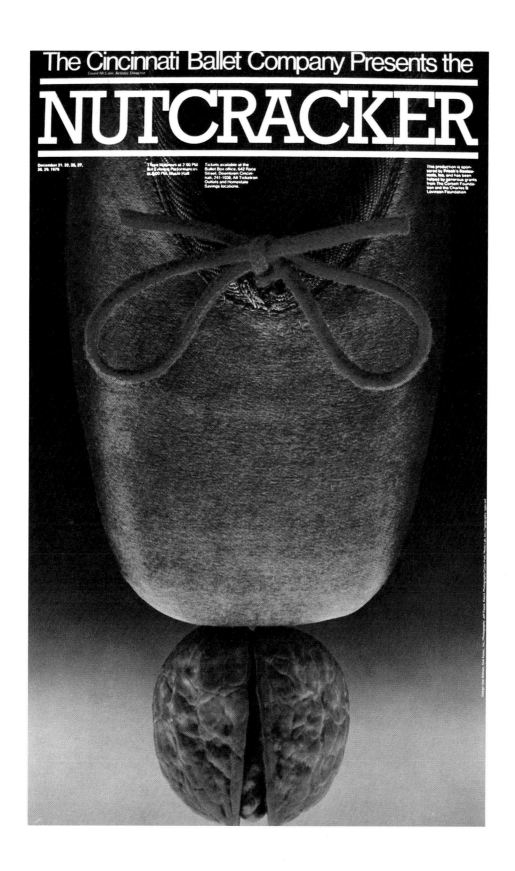

TYPOGRAPHY/DESIGN Dan Bittman
TYPE SUPPLIER Typo-Set, Inc.
AGENCY Sive Associates, Inc.
CLIENT Cincinnati Ballet Company

PRINCIPAL TYPE Body: Helvetica
 Heads: Rockwell
DIMENSIONS 17½ × 28" (45 × 71 cm) Informational/163

TYPOGRAPHY/DESIGN	Bruce Montgomery
TYPE SUPPLIER	Custom Typographic Service
STUDIO	Bruce Montgomery
CLIENT	University Art Museum, Berkeley
PRINCIPAL TYPE	Body: Helvetica
	Heads: Gill Sans
DIMENSIONS	9 × 8″ (23 × 20 cm)

A N S E L

ADAMS

THE SILVER IMAGE GALLERY · SEATTLE
AUGUST 23 TO SEPTEMBER 30, 1979

TYPOGRAPHY/DESIGN	Rick Eiber
TYPE SUPPLIER	The Type Gallery, Inc.
STUDIO	Rick Eiber Design
CLIENT	Silver Image Gallery
PRINCIPAL TYPE	Body: Times Roman
	Heads: Neo-Times Roman
DIMENSIONS	23 × 30¾″ (58 × 78 cm)

Informational/165

EUROPE, 1912-1932

THE PLANAR DIMENSION

THE SOLOMON R. GUGGENHEIM MUSEUM, NEW YORK MARCH 9 – MAY 6, 1979

DESIGN	J. Malcolm Grear
TYPE SUPPLIER	Wrightson Typographers
STUDIO	Malcolm Grear Designers Inc.
CLIENT	Worth Publishers
PRINCIPAL TYPE	Futura Demi Bold/Sabon
DIMENSIONS	22 × 33″ (56 × 84 cm)

Fantastic Illustration and Design in Britain
1850 - 1930

Edward Julius Detmold, "The Story of Baba Abdalla," *The Arabian Nights*, 1924

MUSEUM OF ART, RHODE ISLAND SCHOOL OF DESIGN MARCH 29 - MAY 13, 1979

COOPER-HEWITT MUSEUM JUNE 5 - SEPTEMBER 2, 1979

This project is supported by a grant from the National Endowment for the Humanities in Washington, D.C., a Federal Agency.

The exhibition is supported by a Federal indemnity from the Federal Council on the Arts and the Humanities.

The Museum of Art receives partial support for its programs through an International Support Grant from the Rhode Island State Council on the Arts.

TYPOGRAPHY	William C. Newkirk
DESIGN	J. Malcolm Grear
TYPE SUPPLIER	Dumar Typesetting
STUDIO	Malcolm Grear Designers, Inc.
CLIENT	Rhode Island School of Design Museum
PRINCIPAL TYPE	Body: Sabon
	Heads: Bernhard Tango
DIMENSIONS	22½ × 32″ (57 × 81 cm)

Informational/167

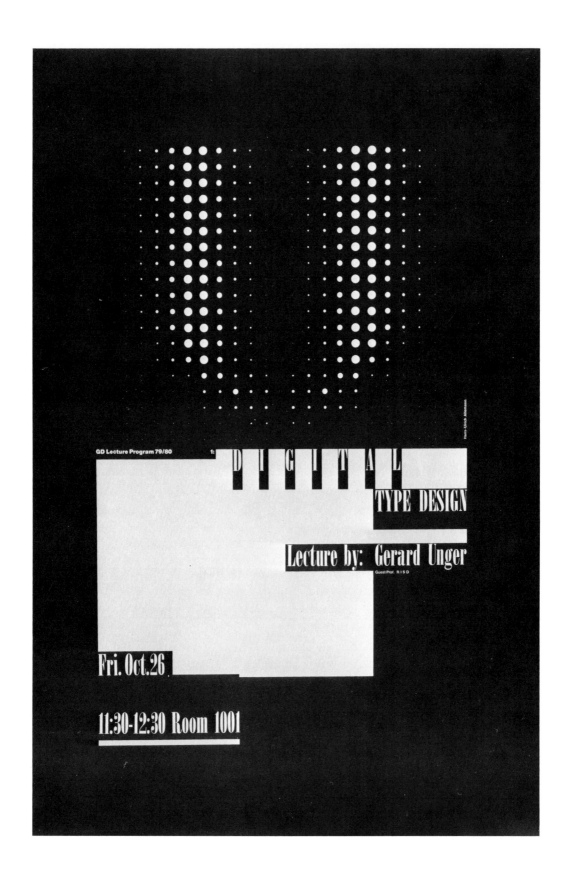

TYPOGRAPHY/DESIGN Hans-U. Allemann
CLIENT Philadelphia College of Art,
 Graphic Design Dept.

PRINCIPAL TYPE Bodoni Compressed
DIMENSIONS 20 × 30" (51 × 76 cm)

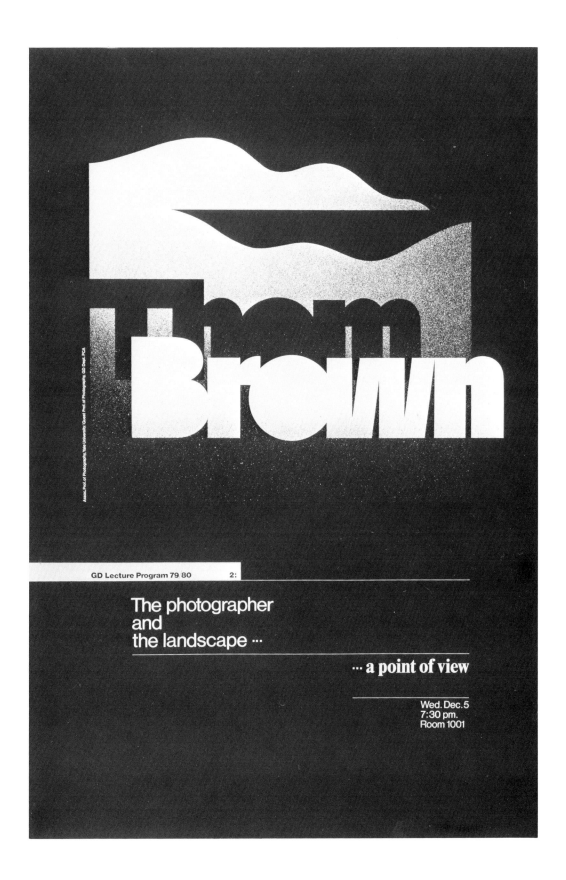

TYPOGRAPHY/DESIGN Hans-U. Allemann
CLIENT Philadelphia College of Art,
Graphic Design Dept.

PRINCIPAL TYPE Body: Helvetica
Heads: Helvetica/Times
DIMENSIONS 20 × 30″ (51 × 76 cm)

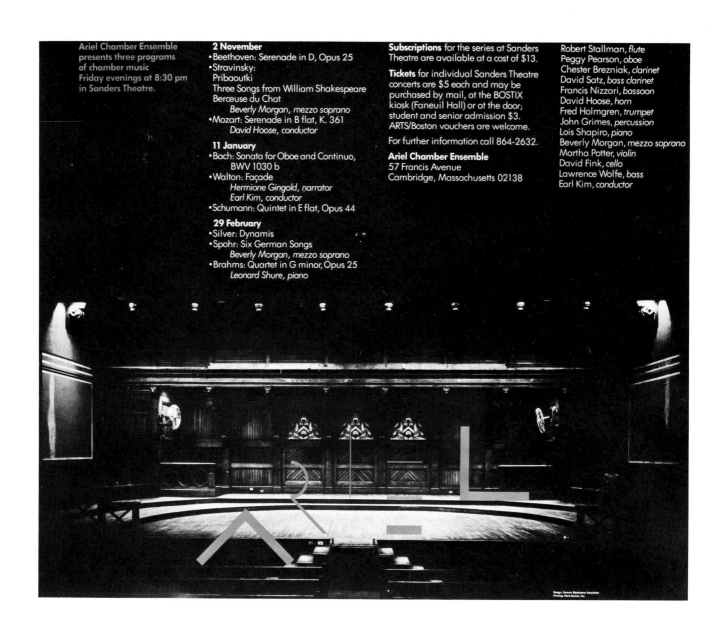

Ariel Chamber Ensemble presents three programs of chamber music Friday evenings at 8:30 pm in Sanders Theatre.

2 November
• Beethoven: Serenade in D, Opus 25
• Stravinsky:
 Pribaoutki
 Three Songs from William Shakespeare
 Berceuse du Chat
 Beverly Morgan, mezzo soprano
• Mozart: Serenade in B flat, K. 361
 David Hoose, conductor

11 January
• Bach: Sonata for Oboe and Continuo,
 BWV 1030 b
• Walton: Façade
 Hermione Gingold, narrator
 Earl Kim, conductor
• Schumann: Quintet in E flat, Opus 44

29 February
• Silver: Dynamis
• Spohr: Six German Songs
 Beverly Morgan, mezzo soprano
• Brahms: Quartet in G minor, Opus 25
 Leonard Shure, piano

Subscriptions for the series at Sanders Theatre are available at a cost of $13.

Tickets for individual Sanders Theatre concerts are $5 each and may be purchased by mail, at the BOSTIX kiosk (Faneuil Hall) or at the door; student and senior admission $3. ARTS/Boston vouchers are welcome.

For further information call 864-2632.

Ariel Chamber Ensemble
57 Francis Avenue
Cambridge, Massachusetts 02138

Robert Stallman, *flute*
Peggy Pearson, *oboe*
Chester Brezniak, *clarinet*
David Satz, *bass clarinet*
Francis Nizzari, *bassoon*
David Hoose, *horn*
Fred Holmgren, *trumpet*
John Grimes, *percussion*
Lois Shapiro, *piano*
Beverly Morgan, *mezzo soprano*
Martha Potter, *violin*
David Fink, *cello*
Lawrence Wolfe, *bass*
Earl Kim, *conductor*

DESIGN	Roger Sametz/Julie Reed/John Kane
TYPE SUPPLIER	Lithocomp
STUDIO	Sametz Blackstone Associates Inc.
CLIENT	Ariel Chamber Ensemble
PRINCIPAL TYPE	Futura
DIMENSIONS	22½ × 18" (57 × 46 cm)

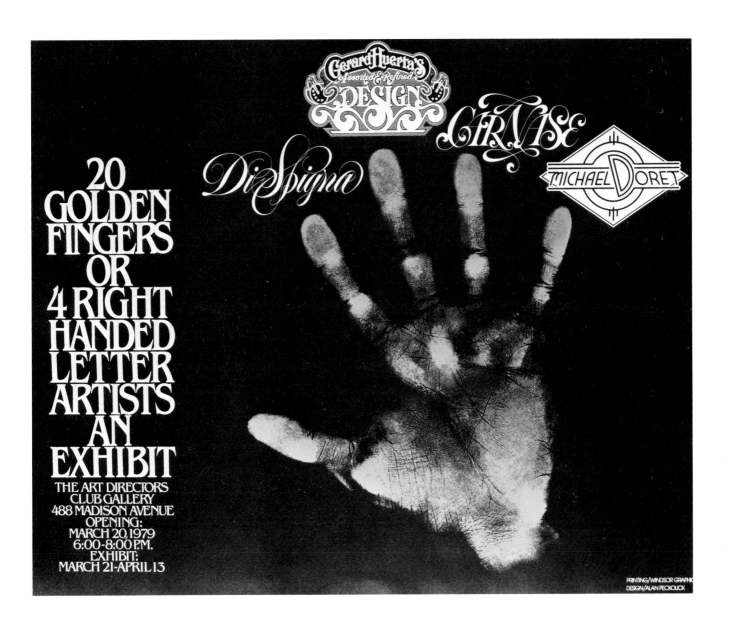

TYPOGRAPHY/DESIGN Alan Peckolick
TYPE SUPPLIER/STUDIO Herb Lubalin Associates Inc.
CLIENT Art Directors Club

PRINCIPAL TYPE Benguiat
DIMENSIONS 14 × 11½″ (36 × 29 cm) Informational/171

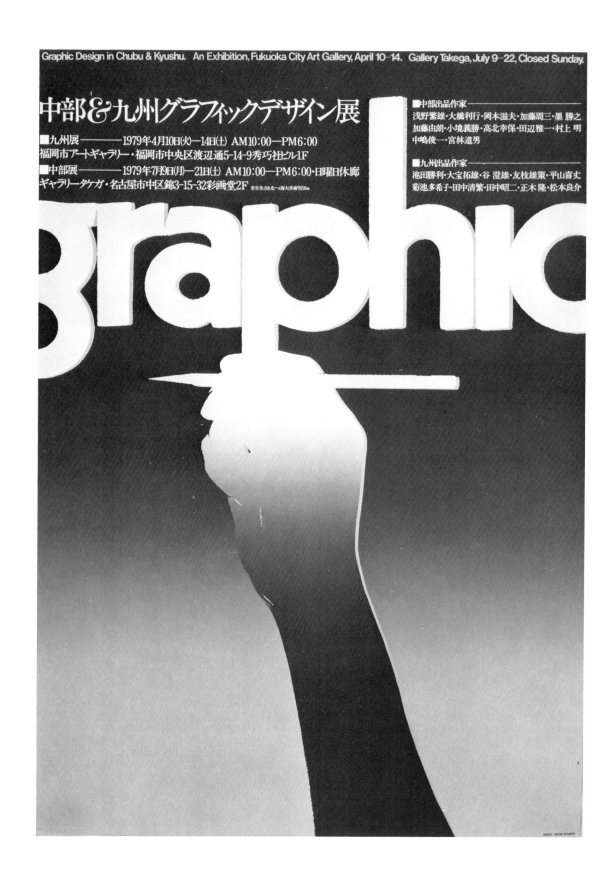

TYPOGRAPHY/DESIGN Shigeo Okamoto
STUDIO Shigeo Okamoto Design Office
CLIENT Gallery Takega

PRINCIPAL TYPE Heads: Kabel Bold
DIMENSIONS 728 × 1030 mm (28⅝ × 40½")

TYPOGRAPHY/DESIGN/
CALLIGRAPHER Shigeo Okamoto
STUDIO Shigeo Okamoto Design Office
CLIENT Aichi Prefecture & Chuba Creators Club

PRINCIPAL TYPE Helvetica Light
DIMENSIONS 728 × 1030 mm (28⅝ × 40½″)

Informational/173

Objects of Bright Pride

NORTHWEST COAST INDIAN ART FROM THE AMERICAN MUSEUM OF NATURAL HISTORY

Denver Art Museum
January 31–March 18, 1979

AN EXHIBITION ORGANIZED BY THE CENTER FOR INTER-AMERICAN RELATIONS AND THE AMERICAN FEDERATION OF ARTS

SUPPORTED BY A GRANT FROM THE NATIONAL ENDOWMENT FOR THE ARTS

TYPOGRAPHY/DESIGN	Leon Auerbach
TYPE SUPPLIER	Unbekant Typographers/George Butner
STUDIO	Leon Auerbach Design Associates
CLIENT	Center for Inter-American Relations/ American Federation of the Arts
PRINCIPAL TYPE	Body: Garamond #3 Heads: Delphin
DIMENSIONS	22½ × 33½" (57 × 85 cm)

Detroit Symphony Orchestra
EUROTOUR '79
Antal Dorati, music director

October 30/
Barcelona, Spain

October 31/
Barcelona, Spain

November 1/
Madrid, Spain

November 3/
Ludwigshafen, West Germany

November 4/
Stuttgart, West Germany

November 6/
Brussels, Belgium

November 7/
Bonn, West Germany

November 8/
Hannover, West Germany

November 9/
Frankfurt, West Germany

November 12/
Paris, France

November 13/
Munich, West Germany

November 14/
Berlin, West Germany

November 15/
Braunschweig, West Germany

November 16/
Düsseldorf, West Germany

November 19/
London, England

November 20/
Stockholm, Sweden

November 22/
Uppsala, Sweden

November 23/
Oslo, Norway

November 24/
Sandefjord, Norway

November 25/
Bergen, Norway

November 27/
Geneva, Switzerland

November 28/
Zurich, Switzerland

November 29/
Lausanne, Switzerland

November 30/
Basel, Switzerland

TYPOGRAPHY/DESIGN	Elizabeth Youngblood
TYPE SUPPLIER	Central Typesetting Company
STUDIO	IGS Design
CLIENT	Detroit Symphony Orchestra
PRINCIPAL TYPE	Body: Garamond No. 3
	Heads: Bauer Initials
DIMENSIONS	22¾ × 36" (58 × 91 cm)

Informational/175

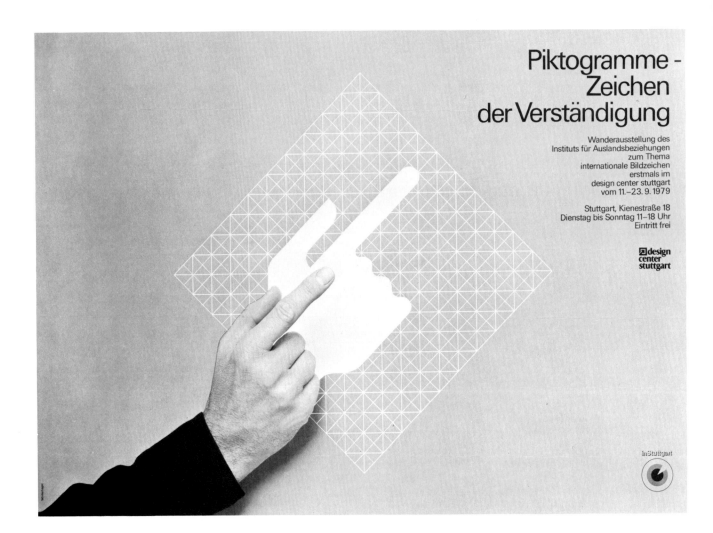

TYPOGRAPHY/DESIGN Klaus Winterhager
TYPE SUPPLIER Manfred Leyhausen, Dusseldorf
CLIENT Design Center, Stuttgart

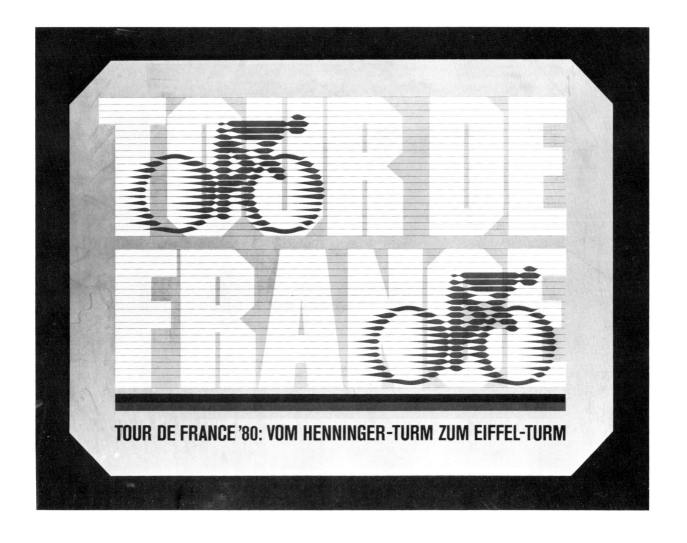

TOUR DE FRANCE '80: VOM HENNINGER-TURM ZUM EIFFEL-TURM

TYPOGRAPHY/DESIGN Olaf Leu
TYPE SUPPLIER Fuerst
CALLIGRAPHER Marta Tomaszewski
AGENCY Olaf Leu Design & Partner/
 DK Public Relations
CLIENT Stadt Frankfurt am Main/Fritz Weber
PRINCIPAL TYPE Body: Univers 67
 Heads: Machine Bold
DIMENSIONS 59.5 × 84 cm (23¼ × 33¹/₁₆″)

Informational/177

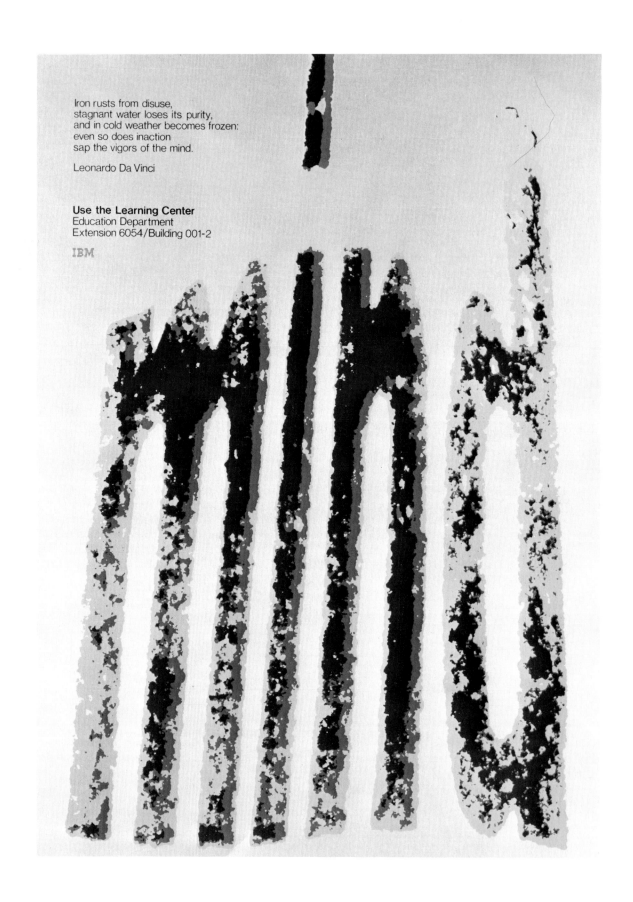

Iron rusts from disuse,
stagnant water loses its purity,
and in cold weather becomes frozen:
even so does inaction
sap the vigors of the mind.

Leonardo Da Vinci

Use the Learning Center
Education Department
Extension 6054/Building 001-2

IBM

DESIGN	Tom Bluhm
STUDIO	IBM Design Services
CLIENT	IBM
PRINCIPAL TYPE	Helvetica Light/Regular
DIMENSIONS	15 × 21″ (38 × 53 cm)

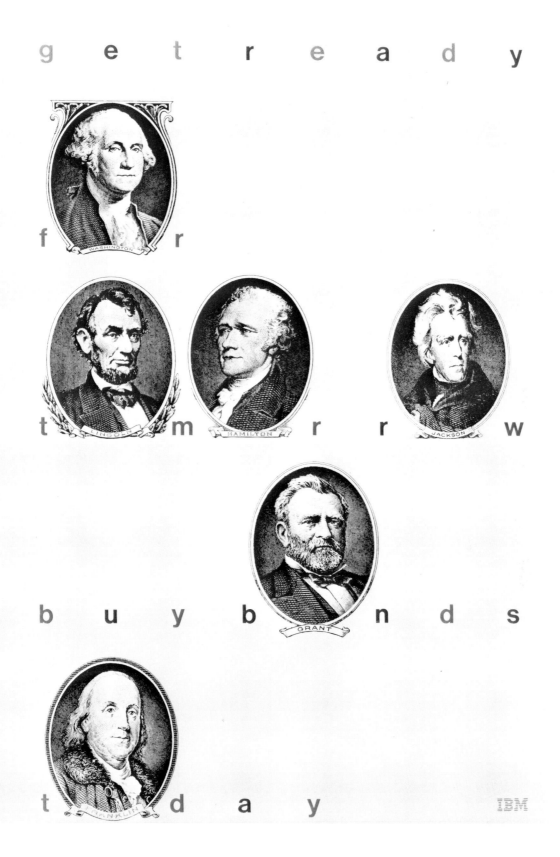

get ready for tomorrow buy bonds today

DESIGN Tom Bluhm
STUDIO IBM Design Services
CLIENT IBM

PRINCIPAL TYPE Helvetica Regular
DIMENSIONS 15 × 21″ (38 × 53 cm)

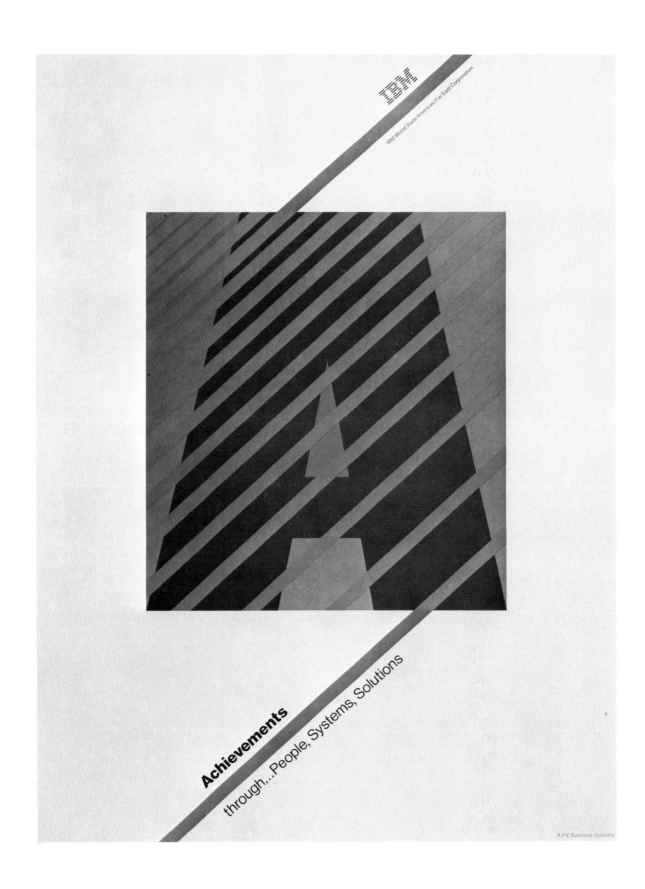

IBM World Trade Americas/Far East Corporation

Achievements

through...People, Systems, Solutions

A/FE Business Systems

TYPOGRAPHY/DESIGN	Arthur Boden/Jerry Mancini
TYPE SUPPLIER	Just Your Type
STUDIO	Arthur Boden Inc.
CLIENT	IBM World Trade
PRINCIPAL TYPE	Univers
DIMENSIONS	20 × 38″ (51 × 97 cm)

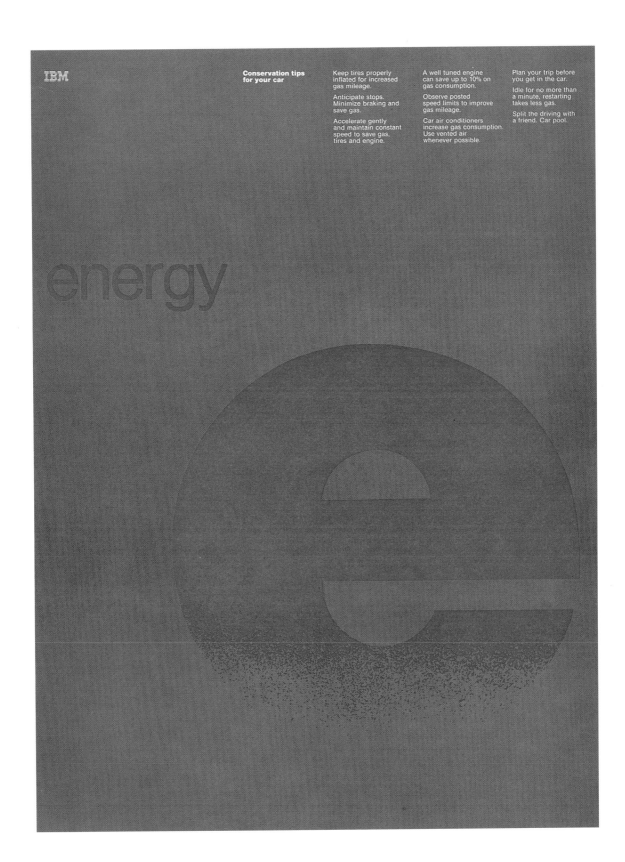

IBM

**Conservation tips
for your car**

Keep tires properly
inflated for increased
gas mileage.

Anticipate stops.
Minimize braking and
save gas.

Accelerate gently
and maintain constant
speed to save gas,
tires and engine.

A well tuned engine
can save up to 10% on
gas consumption.

Observe posted
speed limits to improve
gas mileage.

Car air conditioners
increase gas consumption.
Use vented air
whenever possible.

Plan your trip before
you get in the car.

Idle for no more than
a minute, restarting
takes less gas.

Split the driving with
a friend. Car pool.

energy

TYPOGRAPHY/DESIGN Kurt W. Gibson
TYPE SUPPLIER Tucson Type
STUDIO IBM Tucson Design Center
CLIENT IBM

PRINCIPAL TYPE Helvetica
DIMENSIONS 15 × 21″ (38 × 53 cm)

Informational/181

Burlington Industries

**1978
Annual Report**

TYPOGRAPHY/DESIGN Ingo Scharrenbroich/Arnold Saks
TYPOGRAPHIC SUPPLIER Tri-Arts Press, Inc.
STUDIO Arnold Saks Associates
CLIENT Burlington Industries

PRINCIPAL TYPE Body: Aster
 Heads: Franklin Gothic

 DIMENSIONS 9 × 11½″ (23 × 29 cm)

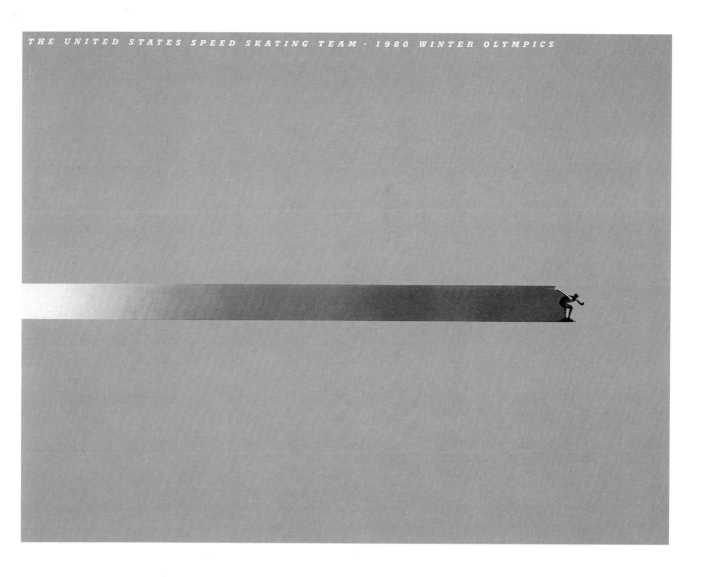

TYPOGRAPHY/DESIGN	David Kaestle/Bob Pellegrini/
	Madelene Lees/Ted Williams
TYPE SUPPLIER	Haber Typographers/TGI
CALLIGRAPHER	Ahza Moore
STUDIO	Pellegrini and Kaestle, Inc.
CLIENT	Champion International Corp.
PRINCIPAL TYPE	Helvetica/Stymie
DIMENSIONS	12 × 9″ (30 × 23 cm)

Informational/183

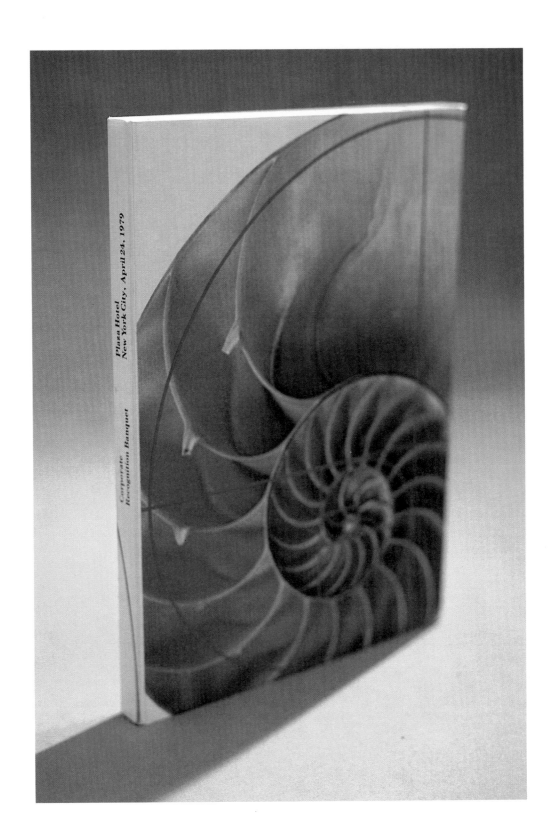

Plaza Hotel
New York City, April 24, 1979

Corporate
Recognition Banquet

TYPOGRAPHY/DESIGN	Richard Rogers/Bonnie Louise Judd
TYPE SUPPLIER	Southern New England Typographic Service
STUDIO	Richard Rogers Inc.
CLIENT	IBM Corporation
PRINCIPAL TYPE	Body: Bodoni Book Heads: Bodoni/Bodoni Italic
DIMENSIONS	11 × 7½″ (28 × 19 cm)

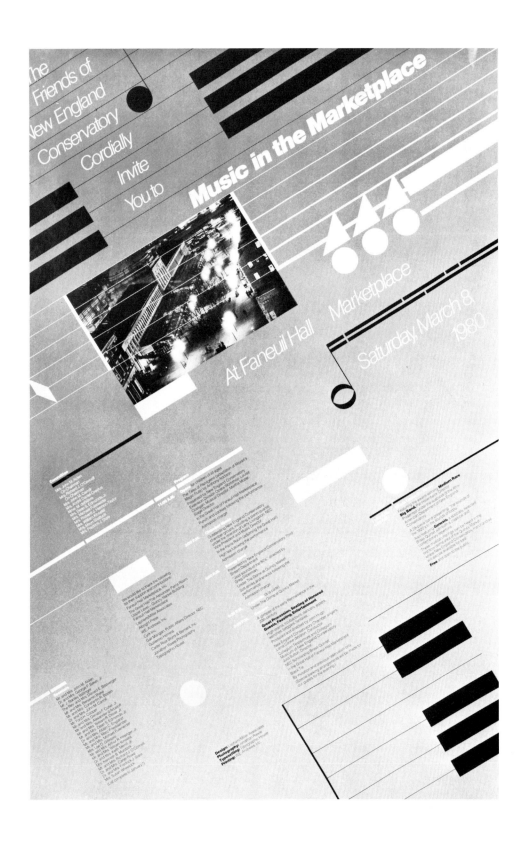

TYPOGRAPHY/DESIGN	Ralph Lapham
TYPE SUPPLIER	Typographic House, Boston
STUDIO	Lapham/Miller Associates, Inc.
CLIENT	New England Conservatory
PRINCIPAL TYPE	Helvetica
DIMENSIONS	23¾ × 37″ (60 × 94 cm)

Informational/185

CBS:
More than
Meets
the Eye

A Pictorial
Essay

*1978
Annual Report
to the
Shareholders
of CBS Inc.*

TYPOGRAPHY/DESIGN Ted Andresakes/Lou Dorfsman
TYPE SUPPLIER TypoGraphics Communications, Inc.
AGENCY CBS/Broadcast Group
CLIENT CBS Inc.

PRINCIPAL TYPE ITC Garamond
DIMENSIONS 8½ × 11″ (22 × 28 cm)

Salomon Brothers

1978

TYPOGRAPHY/DESIGN Bob Pellegrini/David Kaestle
TYPE SUPPLIER Haber Typographers/Salomon Brothers
STUDIO Pellegrini and Kaestle, Inc.
CLIENT Salomon Brothers

PRINCIPAL TYPE Body: Palatino
 Heads: Palatino Italic
188/Informational DIMENSIONS 7½ × 12″ (19 × 30 cm)

Northrop Corporation *Annual Report 1978*

TYPOGRAPHY/DESIGN	Carl Seltzer/James Cross
TYPE SUPPLIER	Vernon Simpson Typographers
CALLIGRAPHER	Michael Manoogian
STUDIO	James Cross Design Office, Inc.
CLIENT	Northrop Corporation
PRINCIPAL TYPE	Garamond
DIMENSIONS	8½ × 11″ (22 × 28 cm)

TYPOGRAPHY Naomi Burstein/Bill Rosner
DESIGN Bennett Robinson/Naomi Burstein
TYPE SUPPLIER TGI/Composet
CLIENT Richardson-Merrell Inc.

PRINCIPAL TYPE Body: Baskerville
 Heads: Plantin Bold

190/Informational DIMENSIONS 17 × 11″ (43 × 28 cm)

TYPOGRAPHY/DESIGN	Michael McGinn/Philip Gips
TYPE SUPPLIER	IGI
STUDIO	Gips + Balkind + Associates, Inc.
CLIENT	Beekman Downtown Hospital
PRINCIPAL TYPE	Body: Times Roman
	Heads: Helvetica
DIMENSIONS	9 × 13½″ (23 × 34 cm)

Informational/191

TYPOGRAPHY/DESIGN Diane Wasserman
TYPE SUPPLIER Chelsea Typographers
AGENCY Hill and Knowlton
CLIENT Beneficial Insurance Companies

PRINCIPAL TYPE Helvetica
DIMENSIONS 8½ × 11″ (22 × 28 cm)

People's tastes change,
but their essential
needs do not vary much.
St. Regis—through its
involvement in printing
papers, newsprint,
packaging materials,
finished packaging,
consumer products,
construction materials,
and hydrocarbons—
has a great deal to do
with meeting basic
human requirements
for communication,
education, distribution,
shelter, and energy.

TYPOGRAPHY/DESIGN Roger Cook/Don Shanosky
TYPE SUPPLIER Typographic Service
STUDIO Cook and Shanosky Associates, Inc.
CLIENT St. Regis Paper Co.

PRINCIPAL TYPE Plantin
DIMENSIONS 8½ × 11″ (22 × 28 cm) Informational/193

75th Anniversary
The Coca-Cola
Bottling Company
of New York, Inc.

Annual Report 1978

TYPOGRAPHY/DESIGN Wayne Roth
TYPE SUPPLIER Unbekant
CALLIGRAPHER Roger Barrows
STUDIO Corpcom Services, Inc.
CLIENT Coca-Cola Bottling Company of NY

PRINCIPAL TYPE Body: Korinna
 Heads: Korinna Heavy

 DIMENSIONS 8½ × 11" (22 × 28 cm)

Whereas, The Association of Junior Leagues, Inc., an organization of 238 member Leagues in the United States, Canada and Mexico, is committed to working on behalf of children and their families to ensure the optimal physical, emotional, intellectual, mental and social growth of children; and *Whereas,* The International Year of the Child is dedicated to ensuring similar rights of children everywhere: *Therefore Be It Resolved, That* The Association of Junior Leagues, Inc. proudly declares the Association's child advocacy program a celebration of the International Year of the Child

Alice H. Weber

President, The Association of Junior Leagues, March 15, 1979

TYPOGRAPHY/DESIGN Elaine Crawford
CALLIGRAPHER Joel Kaden
CLIENT Association of Junior Leagues, Inc.

DIMENSIONS 12 × 18″ (30 × 46 cm)

TYPOGRAPHY/DESIGN	Lou Dorfsman/Tomoko Miho
CALLIGRAPHER	Ikko Tanaka
AGENCY	Lou Dorfsman
CLIENT	International Design Conference in Aspen
PRINCIPAL TYPE	Body: IBM Selectric Typewriter Heads: Didot
DIMENSIONS	5½ × 10⅝″ (14 × 27 cm)

DESIGN Paul Siemsen
TYPE SUPPLIER Western Typesetting, Omaha
STUDIO The Word/Form Corporation
CLIENT The Des Moines Club

PRINCIPAL TYPE Body: Garamond Italic
 Heads: Vespa
DIMENSIONS 7½ × 13″ (29 × 33 cm)

HOW WONDERFUL IT IS,
THIS JOYOUS SEASON,
CELEBRATING AN EVENT WHICH IS
MORE THAN A BEAUTIFUL IDEA, AN EVENT
WHOSE TRUE MEANING IS UNDERSTOOD
WHEN WE LET THE SPIRIT BE REFLECTED
IN OUR HEARTS.

TYPOGRAPHY/DESIGN Steven Sessions
TYPE SUPPLIER Professional Typographers
CALLIGRAPHER Steven Sessions/Harrison Allen
AGENCY/CLIENT Baxter + Korge, Inc.

PRINCIPAL TYPE Goudy Old Style
DIMENSIONS 10 × 10″ (25 × 25 cm)

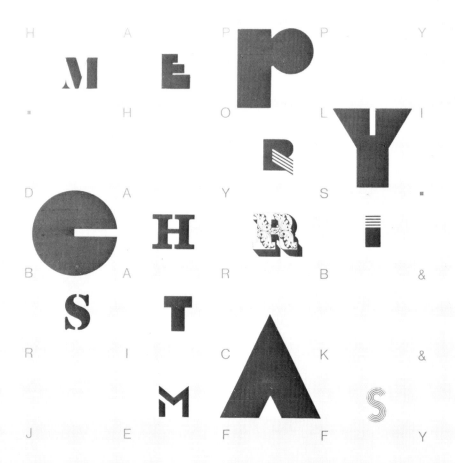

TYPOGRAPHY/DESIGN Richard Klein
TYPE SUPPLIER Drager & Mount Typographers/
 Letraset
STUDIO Raychem Design Center
CLIENT Klein Family

DIMENSIONS 15 × 16″ (38 × 41 cm) Informational/199

TYPO GRAPHIC HOUSE

TYPO GRAPHIC HOUSE
63 MELCHER STREET
BOSTON, MA 02210

63 MELCHER STREET, BOSTON, MASSACHUSETTS 02210 PHONE (617) 482-1719

TYPOGRAPHY/DESIGN	James H. Moore
TYPE SUPPLIER/CLIENT	Typographic House, Boston
CALLIGRAPHER	Dietmar Winkler
PRINCIPAL TYPE	Body: News Gothic Light
	Heads: Firenze
DIMENSIONS	8½ × 11″ (22 × 28 cm)

GOLF TRADING COMPANY, INC.
21 WEST 35TH ST.
NYC, N.Y. 10001
(212) 563-6895
13 EAST 47TH ST.
NYC, N.Y. 10017
(212) 759-3362

GEORGE BOSS

GOLF TRADING COMPANY, INC.
21 WEST 35TH ST.
NYC, N.Y. 10001
(212) 563-6895
13 EAST 47TH ST.
NYC, N.Y. 10017
(212) 759-3362

GOLF TRADING COMPANY, INC.
21 WEST 35TH ST.
NYC, N.Y. 10001
13 EAST 47TH ST.
NYC, N.Y. 10017

TYPOGRAPHY/DESIGN Roger Ferriter
TYPE SUPPLIER/
CALLIGRAPHER Tom Carnase
STUDIO Roger Ferriter, Inc.
CLIENT Golf Trading Co., Inc.

PRINCIPAL TYPE Body: Avant Garde Book
 Heads: Avant Garde Bold

TYPOGRAPHY/DESIGN	Blair Kerrigan/Robert Burns
TYPE SUPPLIER	Qualitype
STUDIO	Glyphics
CLIENT	City of Toronto, Mayors Office
PRINCIPAL TYPE	Palatino

TYPOGRAPHY/DESIGN John R. Rieben
TYPE SUPPLIER Drager & Mount Typographers
CLIENT American Institute of Graphic Arts

PRINCIPAL TYPE Helvetica Informational/203

TYPOGRAPHY/DESIGN Douglas David
TYPE SUPPLIER Weimer Typesetting/Jerry Moss
STUDIO/CLIENT Douglas David Design
PRINCIPAL TYPE Souvenir

TYPOGRAPHY/DESIGN Holley Flagg
TYPE SUPPLIER Pastore DePamphilis Rampone
CALLIGRAPHER Holley Flagg
STUDIO The Vanderpool Group
CLIENT Great Performance Tours

PRINCIPAL TYPE ITC Garamond

TYPOGRAPHY/DESIGN Richard Foy
TYPE SUPPLIER Ernie Brame Typecrafter Company
STUDIO Communication Arts, Incorporated
CLIENT Northstar Studios

Theater, Delphi
April 20, 1970

DESIGN Rudolph de Harak
TYPE SUPPLIER Innovative Graphics International
STUDIO Rudolph de Harak & Associates, Inc.
CLIENT School of Architecture, Cooper Union

PRINCIPAL TYPE Garamond
DIMENSIONS 7¾ × 7¾" (20 × 20 cm) Informational/207

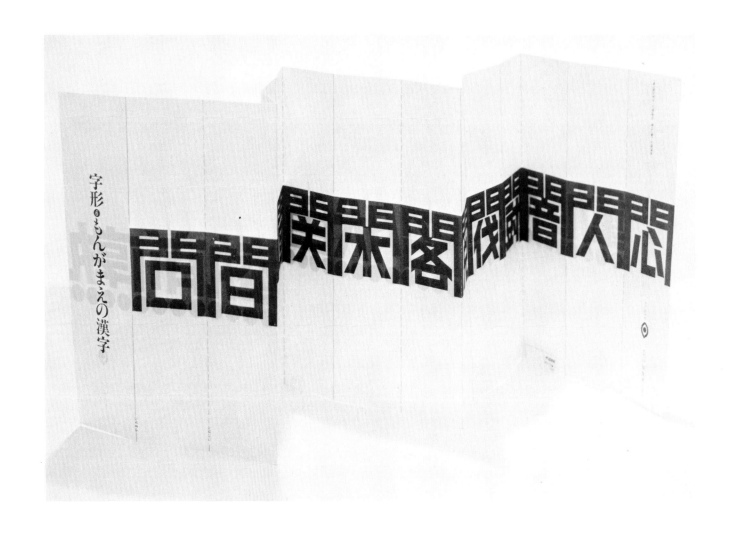

字形⑥もんがまえの漢字

TYPOGRAPHY/DESIGN/
CALLIGRAPHER Tadashi Mizui
CLIENT GROUP TYPO-EYE

DIMENSIONS 20 × 20 cm (8 × 8″)
 72 × 72 cm (28¼ × 28¼″)

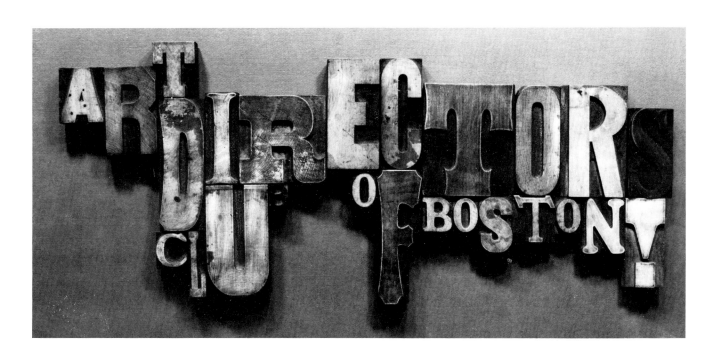

TYPOGRAPHY/DESIGN	Joanne Hetherington
TYPE SUPPLIER	Charles Banks, Designers
STUDIO	Joanne Hetherington/Communications Design
CLIENT	Art Directors Club of Boston
DIMENSIONS	12 × 25½″ (30 × 65 cm)

Informational/209

TYPE DIRECTORS CLUB OFFICERS 1979–1980

President	William Streever
First Vice President	Bonnie Hazelton
Second Vice President	Stan Markocki
Secretary	Minoru Morita
Treasurer	Robert Spurgeon
Governor-at-Large	Bernhard J. Kress
Chairman Board of Governors	Roy Zucca

TYPE DIRECTORS CLUB OFFICERS 1980–1981

President	Bonnie Hazelton
First Vice President	Stan Markocki
Second Vice President	Robert Spurgeon
Secretary	John Luke
Treasurer	Roy Zucca
Governor-at-Large	Gene Krackehl
Chairman Board of Governors	William Streever
Executive Secretary	Jerry Singleton
Offices	12 East 41st Street, New York, N.Y. 10017
Telephone	212-683-6492

COMMITTEE FOR TDC-26

Chairman	John Luke
Co-Chairmen	Roy Zucca, Walter Stanton
Coordinator	Jerry Singleton
Assistant Coordinator	Joan Kan
Call for Entries	
Design	John Luke
Typographic Supplier	TypoGraphic Communications
Printing	Milo Press
Calligraphy	Robert Boyajian
Receiving Facilities	Ad Agencies/Headliners
Traffic	Jay Berman

Thirty-two-page catalogs of several previous
Type Directors Club Exhibits are avail-
able from the offices of the Type Directors
Club at $1.50 each postpaid.

TYPE DIRECTORS CLUB MEMBERSHIP LIST 1980

Kelvin J. Arden
Leonard F. Bahr
Don Baird
Arnold Bank**
Clarence Baylis
Edward Benguiat
Ted Bergman
Peter Bertolami
Emil Biemann
Godfrey Biscardi
Roger Black
Art Boden
Friedrich Georg Böes
Ed Brodsky
Werner Brudi
Bernard Brussel-Smith
Bill Bundzak
Aaron Burns
Joseph E. Camolli
Tom Carnase
Alan Christie
Travis Cliett
Mahlon A. Cline
Tom Cocozza
Robert Adam Cohen
Freeman Craw
James Cross
Ray Cruz
Thomas Dartnell
Ismar David
Whedon Davis
Robert Defrin
Cosmo DeMaglie
Ralph DiMeglio
Louis Dorfsman
John Dreyfus**
Curtis Dwyer
Joseph M. Essex
Eugene Ettenberg
Elizabeth Fabian
Bob Farber
Sidney Feinberg
Roger Ferriter

Glenn Foss*
Dean J. Franklin
Stuart Germain
Vincent Giannone
Lou Glassheim
Howard Glener
Edward Gottschall*
Sandi Governale
Norman Graber
Austin Grandjean
Allan Haley
James J. Halpin
Horace Hart
Bonnie Hazelton
Art Heron
Russell Ingui
Donald Jackson**
Mary Jaquier
Peter W. Jedrezejek
Allen Johnston
R. M. Jones
R. Randolph Karch**
Louis F. D. Kelley
Michael O. Kelly
Tom Kerrigan
Lawrence Kessler
Wilbur King
Peggy Kiss
Zoltan Kiss
Richard Knysz
Steve Kopec
Gene Krackehl
Bernhard J. Kress
James Laird
Mo Lebowitz
Arthur Lee
Acy R. Lehman
Louis Lepis
Robert Leslie**
Olaf Leu
Irving Levine
Manfred Leyhausen
Ben Lieberman
Clifton Line

Wally Littman
John Howland Lord*
Anthony Loscalzo
Herb Lubalin
John Luke
June MacLennan
Sol Malkoff
Marilyn Marcus
Stanley Markocki
John S. Marmaras
Frank Marshall III
James Mason
Jack Matera
Frank Mayo
Fernando Medina
Egon Merker
Douglas Michalek
R. Hunter Middleton**
Paul D. Miller
John Milligan
Oswaldo Miranda
Barbara Montgomery
Ronald Morganstein
Minoru Morita
Tobias Moss
Keith Murgatroyd
Louis A. Musto
Alexander Nesbitt
Ko Noda
Jack Odette
Thomas Ohmer
Motoaki Okuizumi
Brian O'Neill
Gerard J. O'Neill*
Professor G. W. Ovink**
Zlata W. Paces
Robert C. Parmelee
Eugene P. Pattberg
Raymond Pell
George Podorson
Roy Podorson
Louis Portuesi
Erwin Raith
Ernst Reichl

Ed Richman
Jack Robinson
Edward Rondthaler*
Robert M. Rose
Herbert M. Rosenthal
Sal Sabaj
Gus Saelens
Fred C. Salamanca
Bob Salpeter
David Saltman
Arthur Sammartino
John N. Schaedler
Klaus F. Schmidt
Sheldon Seidler
William L. Sekuler*
Elizabeth Sheehan
Richard Silverman
Martin Solomon
Harvey R. Spears
Vic Spindler
John Sposato
Robert Spurgeon
Walter Stanton
Herbert Stoltz
William Streever
Ken Sweeny
William Taubin
Jack Tauss
Anthony J. Teano
Bradbury Thompson
Professor Georg Trump**
Lucy Tuttle
Edward Vadala
Jan van der Ploeg
Joe Venturini
Jurek Wajdowicz
Herschel Wartik
Kurt Weidermann
Hal Zamboni*
Hermann Zapf**
Ray Zimmerman
Roy Zucca
Milton Zudeck*

SUSTAINING MEMBERS

Ad Agencies/Headliners
Arrow Typographers Inc.
M.J. Baumwell Typography
Craftsman Type Inc.
Harris Composition Systems
International Typeface Corp.
Mergenthaler Linotype Company
Pastore DePamphilis Rampone
Photo-Lettering Inc.
Royal Composing Room

Spindler Slides
Techni-Process Lettering
Tri-Arts Press Inc.
TypoGraphics Communications Inc.
TypoGraphic Designers
Typographic House, Boston
Typographic Innovations Inc.
Typovision +
Volk & Huxley

*Charter Member
**Honorary Member

INDEX

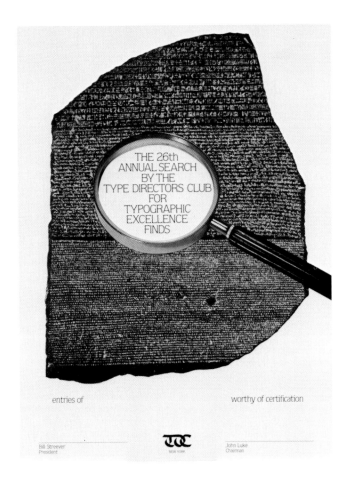

THE 26th
ANNUAL SEARCH
BY THE
TYPE DIRECTORS CLUB
FOR
TYPOGRAPHIC
EXCELLENCE
FINDS

entries of worthy of certification

Bill Streever
President

TDC
NEW YORK

John Luke
Chairman